Childhood Revealed
Art Expressing Pain, Discovery & Hope

Foreword by Katie Couric

Edited by
Harold S. Koplewicz, M.D., Director, New York University Child Study Center
Professor of Clinical Psychiatry and Pediatrics, New York University
School of Medicine
and
Robin F. Goodman, Ph.D., Clinical Assistant Professor in Psychiatry,
New York University School of Medicine

General text by Margery D. Rosen

Photography by John Bigelow Taylor

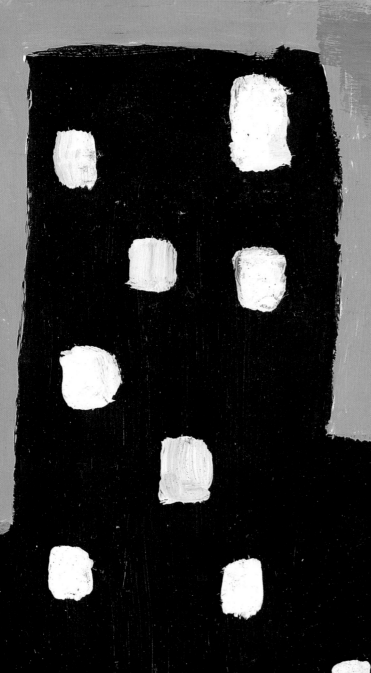

Childhood Revealed
Art Expressing Pain, Discovery & Hope

Harry N. Abrams, Inc.,
Publishers

Dedication

To my children and to children everywhere — HSK
To my parents and to parents everywhere — RFG

Editor: **Ruth A. Peltason**
Designer: **Ana Rogers**

Page 1: Female, 16 years old. **My Picture** (detail). 1977, Acrylic

The New York University Child Study Center thanks Mary Burdick for coordination of the artwork.
All of the author proceeds of *Childhood Revealed* are being donated to the NYU Child Study
Center for the advancement of child mental health. For more information about the
New York University Child Study Center please contact www.nyuchildstudycenter.com

Library of Congress Cataloging-in-Publication Data

Childhood revealed : art expressing pain, discovery & hope / foreword by Katie Couric ;
edited by Harold S. Koplewicz and Robin F. Goodman ; general text by Margery D. Rosen.
p. cm.
ISBN 0-8109-4101-5
1. Child psychopathology — Popular works. 2. Children's art — Psychological aspects.
3. Child mental health. I. Koplewicz, Harold S. II. Goodman, Robin F. III. Rosen, Margery D.
RJ499.34.C48 1999
618.92'89 — dc21 99-17415

Printed and bound in Hong Kong

Harry N. Abrams, Inc.
100 Fifth Avenue
New York, N.Y. 10011
www.abramsbooks.com

Contents

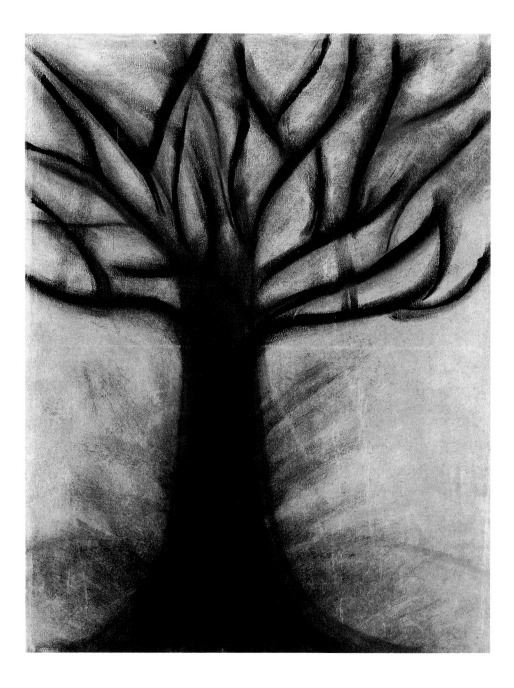

Female, 17 years old. **Adagio: A Movement in Slow Time**, 1998. Chalk pastel, 12 x 9"

When I drew this tree I felt intense emotions. The tree is me. It lacks color and has a sense of anger, sadness, and regret. The tree like me is dark, but still gives off life and energy. It is strong, highlighted with color and goodness. It is self-sufficient and firmly grounded.

Acknowledgments

Creating a book like this has taken the vision of a few and the hands of many. In its infancy, New York University (NYU) Child Study Center board members Gail Furman, Ph.D., Ann Tenenbaum, and Brooke Garber Neidich stepped up to the plate with relentless commitment. Ellen Taubman was also convinced early on of the supreme importance of this book and exhibit, and has been a constant guide, companion, voice of reason, necessary critic, and enthusiast. It was at their urging and outreach that we were able to enlist the initial springboard promise from David Ross, former Director of the Whitney Museum of American Art, to host the debut of this art. From the NYU School of Medicine we would like to thank Dean Robert Glickman; Dr. Robert Cancro, Chairman of the Department of Psychiatry; and John Deeley, Vice-Dean for Administration for believing in this project and allowing it to happen. At Harry N. Abrams, Inc., Paul Gottlieb took this book under his wing, sensing something unique and profound in its content, and worthy of a real art book. Ruth Peltason, the senior editor at Abrams in charge of this project, has been a stalwart champion providing the ultimate in guidance, vision, and words when we offered images, ideas, and thoughts. Our book designer, Ana Rogers, has transformed the children's art and writing into an art book any young artist would be proud of. We thank Kathy Schulz, our legal counsel, for her diligence. We are indebted to Katie Couric, who believes in the mission of this book, exhibit, and campaign and graciously added her signature blend of sensitive journalist and consummate parent to the foreword.

The art shown in this book is only a fraction of what we received from therapists, educators, and even parents throughout the country. A distinguished panel of jurors took on the sobering task of exhaustively reviewing the submissions in an effort to distill what was most powerful and important. We thank Jennifer Bartlett, Paul Goldberger, Al Ravitz, M.D., Kathy Schwartz, Linda Sirow, and Eugenie Tsai, Ph.D. Without their input, this would still be a pile of slides. We also applaud and thank the individuals who live in the public eye — Christine Andreas, Dick Cavett, Christina Crawford, Whoopi Goldberg, Melissa Joan Hart, Ted Kennedy, Jr., Deborah Norville, John Stossel, and Harry Winkler — who agreed that telling their own stories could make others take notice and feel less alone with their problems.

The sheer enormity of the organizational task of soliciting art, cataloguing it, handling it with care, managing minute details and more has been unfailingly and superbly handled by Mary Burdick, Special Projects Administrator at the NYU Child Study Center. We are also grateful to Margery D. Rosen, who gave her voice to the difficult issues addressed within the text, and is the writer responsible for meshing the disparate chapter experts' styles into a cohesive, sensible, user-friendly format. We also thank Amy Hatkoff, whose persistence paid off by garnering the support of well-known personalities who agreed to share their story via personal anecdotes.

Friends, family, and colleagues never tired of hearing about the latest triumph or glitch related to this project, and for that we are continually awed and buoyed, as well as grateful. We must also publicly acknowledge and thank those who understood that when deadlines took over, other work had to take a back seat. But the real tribute and thanks go to the hundreds of children who made the art and to the adults who guided them through this process. There were many therapists who heeded our call for art, answering the request to search their files and approach the children and parents they see in private to find something befitting a public forum such as this book. Here you see only a small product of the youngsters' efforts. Every day children, parents, and the professionals who help them do much more than paint, draw, or sculpt. Each piece of art represents only a fraction of the effort spent over many weeks, months, or years patiently waiting for hope, insight, and change. It is to the children and families who find themselves in difficult circumstances, facing a life-changing crisis, or with a psychiatric illness that we owe our greatest appreciation. The children whose art is revealed here is testament to the gentle care offered by hundreds of adults every day, and most importantly, to the potential of all children everywhere.

Foreword
by Katie Couric

THERE ARE DAYS WHEN IT SEEMS THAT JUST LOVING MY CHILDREN IS THE EASIEST JOB IN THE world, and there are days when I wonder if that is enough. Helping a child through the normal rough-and-tumble crises of childhood—an ear infection, a failed test, or rejection by a friend— is the job of all parents. Endless worrying comes with the territory once you assume the responsi- bility of parenthood. But for the millions of adults who parent one of the eight million children challenged by problems like those discussed in these pages, the search for answers is ever-present. As you read on, you may find answers to some of your own questions. *Childhood Revealed* is for any parent in the midst of a divorce, who has a physically ill or abused child, or who has a child with a learning difference, behavior problem, or psychiatric illness. The suggestions offered here are within the reach of every child and family.

I know I'm blessed to have children who don't suffer from problems such as the ones chron- icled here. Not only do my children bring me unending delight, they also force me to look at what is important in life. When my husband died, it left a huge hole in my family—for me and my girls. I began to understand more clearly what it must be like to parent a child who is not just sad, but who is depressed and unable to find pleasure in life, or who lives with extreme emotional stress and who struggles to feel safe.

The journalist and mother in me tells me that getting to the bottom of things is empower- ing and can bring relief. My skills as a reporter have proved to be good training for being a parent: I know how to investigate things, I know I must respect who I am interviewing, and I know I must follow up whatever I find. I believe parents need the same skills. I strive to truly listen to my kids, to understand their world, and to give them the strength and strategies they need to succeed. I like to think that if I discovered one of my daughters was troubled by the types of problems revealed here, I would do whatever it takes to make her better.

I have learned some important lessons from dealing with the medical and emotional upheavals I've confronted in my own life. First, that paying attention to signs of troubles goes a long way toward fixing current ones or preventing those down the road. Next, that once discovered, taking action about a problem is crucial. Ignoring a situation and putting your head in the sand only pro- longs the inevitable need to get help and it usually makes matters worse. Last, enormous comfort comes from realizing you are not alone and that others understand what you are facing.

This book was created with these things in mind. The art and writings here put a real face on real problems. Learning how to support a child or teen challenged by learning, by a behavior disorder, or by a psychiatric illness brings parents and children one step closer to fully realized lives. But this only happens when we parents have solid information and the opportunity to avail ourselves of finding solutions. I hope that picking up this book is a good first step. *Childhood Revealed* shows what is being done by the New York University Child Study Center in their efforts to increase public awareness. Education is crucial, not just at home but in the classroom too. Nowadays kids learn everything in school, from geography to AIDS prevention. They should also learn about common mental health problems.

I really believe that by opening our eyes we can look with compassion at the kinds of problems our children deal with. The remarkable thing is how kids have so much courage and so much hope—no matter how steep the hill. And my hope is that as we learn about our kids, we will also become a nation of better parents.

Improving children's mental health is everyone's business and rests in all our hands. As a society it is our responsibility to nurture our youth as an investment in their future. We should demand that the scientific rigor that accompanies research into heart disease and cancer be applied to refining the diagnoses and treatment of psychiatric illness in children.

I was only a child when we sent a man to the moon, but even then I sensed the thrill of conquering what seemed unreachable and unknown. It is time to expand a different kind of horizon and invest our resources into learning all we can about that complex human frontier, the mind. It is a vast and untapped world with tremendous potential for all of us. Just as we've learned that parents aren't to be "blamed" for their children's problems, we need to take the next and bigger step—trusting that honesty, understanding, and education can help all of us. We know that great change lies in a partnership between a public in need of answers and the professionals searching for cures. Our best work will be done when the mental health community collaborates with parents and the children themselves.

Introduction

IT'S ALWAYS DIFFICULT TO SEE A CHILD STRUGGLE WITH ANY TYPE OF PROBLEM, ALL THE MORE SO WHEN that problem is treatable and the suffering unnecessary. The New York University Child Study Center, as well as this book, was created to help bring awareness, deepen understanding, and find solutions for the millions of children living with psychiatric and psychological problems.

In the United States more than twelve percent of all children endure some type of mental health problem:

Two million adolescents suffer from depression

Five percent of youth have learning problems

At least one child in every classroom has attention deficit hyperactivity disorder

Three to five percent of teenage girls have eating disorders, and an increasing number of children are being diagnosed as young as age nine or ten

More troubling than these figures, however, is the fact that fewer than twenty percent of these children receive the treatment they need. Many people simply don't recognize that children have serious emotional and psychiatric problems that require our attention and treatment.

The newly established NYU Child Study Center is dedicated to the understanding, prevention, and treatment of child mental health problems. The Center's mission integrates state-of-the-art research, patient care, and training with an emphasis on public awareness to help shatter the myths and erase the stigmas surrounding psychiatric illness, learning differences, trauma, and other mental health problems. The NYU Child Study Center is a place where parents come for premiere diagnosis and treatment for their children with emotional, behavioral, and learning problems. It's a place where the next generation of research is being conducted to advance scientific understanding and treatment of psychiatric disorders. The NYU Child Study Center is an alliance among parents, educators, and professionals. It's a place where we are establishing new models for training mental health specialists and educators and creating new ways of delivering effective care.

Our research investigating new treatments for children and teenagers with anxiety disorders will change the lives of children by helping them to attend school, enjoy their friends, and have fun. Our violence-prevention efforts will hopefully break the cycle of violence and give children a chance to lead productive lives. Our NYU Summer Program for Kids is just one of our treatment models that help children with attention deficit hyperactivity disorder learn new social skills that help them feel more accepted and comfortable all year round. Our planned programs include the use of Magnetic Resonance Imaging, a resource for the understanding of the specific brain differences of children with learning problems and developmental disorders, which in turn leads us to the development of new interventions.

ParentCorps, our exciting initiative funded by the U.S. Department of Education, will disseminate scientifically supported parenting strategies to parents from economically disadvantaged neighborhoods through

parent-to-parent networks. In addition, our web site *(www.nyuchildstudycenter.org)* provides a forum for delivering information and translating research and clinical advances to parents, children, and service providers throughout the country.

Childhood Revealed is the culmination of the efforts of many children, professionals, child advocates, and celebrities. We contacted professionals around the country who in turn asked their patients to contribute work for this book. We received well over 600 pieces of art by children ranging in age from 4 to 18 years. To manage the difficult task of choosing the final images for publication, we formed a jury representing a wide range of disciplines and areas of expertise. Our panel included Jennifer Bartlett, a New York–based artist whose work has been shown internationally; Paul Goldberger, a writer for *The New Yorker* and former cultural editor of *The New York Times*; Alan Ravitz, M.D., Director of Child Psychiatric Inpatient Services at the University of Chicago; Kathy Schwartz, whose child had leukemia and struggles with learning problems; Linda Sirow, an art therapist and artist who currently teaches at the Dalton School in Manhattan; and Eugenie Tsai, Ph.D., Associate Curator at the Whitney Museum of American Art.

To further illuminate the children's messages, we asked experts in such fields as autism, divorce, depression, and anxiety for the most current and practical information so that parents, teachers, mental health professionals, and advocates can better help children and their families. To bring further attention to the children's stories, we also asked celebrities and child advocates to share their own personal experiences with psychiatric illness, learning differences, and trauma.

Childhood Revealed is one of the NYU Child Study Center's efforts to educate the public so that parents will be better able to identify and accept when their child has a mental disorder. If we do our jobs well, adolescent depression will get the same amount of federal research funding as cancer, attention deficit hyperactivity disorder will receive the same clinical excellence as diabetes, and the American public will be just as aware of bipolar disorders, autism, and anxiety disorders as it is about heart disease and hypertension.

I believe that all parents want the same things for their children. They want their kids to have a full and satisfying life, to go to school, to make friends, to have fun. But if a child is too distracted, too learning-disabled, too anxious or too depressed, then he or she doesn't get to take advantage of what life has to offer. Children with mental disorders are like all other children. They have the same hopes and dreams. Their minds are full of images of pain, discovery, and hope. *Childhood Revealed* offers a glimpse into the hearts and minds of children dealing with psychiatric and emotional problems. I hope that as you read the children's words and experience their very personal artistic expressions you will choose to dedicate your time, energy, and resources to giving children with mental disorders and emotional problems the same opportunities as all children. Our goal for this book and the NYU Child Study Center is at once extraordinary and yet exquisitely simple: to end the suffering of children with mental disorders, to reassure their parents that there is hope, and to guide each child toward a happier, richer life.

Harold S. Koplewicz, M.D.
Director, NYU Child Study Center
Director, Division of Child and Adolescent Psychiatry, Bellevue Hospital Center
Professor of Clinical Psychiatry and Pediatrics
New York University School of Medicine

Guide for the Reader

By Robin F. Goodman, Ph.D., A.T.R.-BC

CHILDREN LEAVE THEIR MARK ON THE WORLD IN ANY NUMBER OF WAYS. THEY COME TO KNOW THEY EXIST by seeing the results of their actions. They make a mud pie after a rain storm, scribble a free-form circle with a chunk of crayon, and build a sand castle at the waters' edge. The evidence is clear, something that originated from within becomes public. There is curiosity, learning, exploration, skill, and delight. They realize that feelings and thoughts can be communicated to the outside world. Art made by children provides a window into their world: it offers a view of who they are, regardless of the suffering or pain they may endure. Because children struggle in their quest to cope with a challenge, or strive to compete with forces that mitigate the natural order of things, children in turmoil create with a discernible purpose and need.

The art in this book is by youngsters who have more than the usual story to tell. Their art provides us with a glimpse into a life that is not necessarily the norm nor easy. Each child's life is entwined with, and encompassed by, a particular problem. The children who live with challenges highlighted here—whether it's developmental, situational, psychiatric, or physical—have boldly and candidly given us access to what is usually kept private.

Why This Art

The art in *Childhood Revealed* is a vehicle for understanding a childhood some may call less than perfect. The problems surveyed and illustrated range from the seemingly mild to the extreme, and may be either emotional or physical. Some youngsters may die from tumors or from suicide, others may struggle to read or to quiet the noisy voice of anxiety. For some of these children, medication provides relief for hyperactivity or depression.

The harshness of some of the work correlates with the nature of some circumstances. The profound influence that a particular illness, like schizophrenia or cancer, can have on a young person's life is reflected in the drawings. The seriousness of purpose in their lives and the struggle to adjust to, and conquer, their ills imbues the art with a richness of content and personal meaning that cannot and should not be ignored. All of the drawings show us kids who are doing their best to communicate with all of us.

Any physical or emotional scar suggested by an image provides only a hint of any internal wound. And yet, these children do not necessarily want or need your pity. Many of their pieces allow us to imagine, and be assured, that some of them have found the right mix of self-designed salve and outer sustenance to successfully live unrestricted by their travails. The children profiled here are role models for anyone facing genuine problems.

What To Think About The Art

For most of us, rainbows, suns, and houses are routine forms in children's art. While these images may be evident here, their intent is about something more complex and less familiar than it is for other children. And that means that as the viewer you must first remove any prejudices and free yourself of preconceptions that might obstruct your observations. Thus will you be better equipped to see what is brought to light in

the art and to the more poignant — and covert — meaning. What may seem obvious is in fact part of something deeper and often hidden. As you spend time looking at these pictures and thinking about the commentaries written by the children, a deeper and tender understanding will be your reward.

A piece of graffiti may look clichéd until you read what the children have to say about themselves or their particular drawing. You may find the rendering of a house on stilts inventive or clever until you read that the child comes from a divorced family and that for him or her the "stilted" house is a lonely house. And don't think that every face with a smile describes a present state of being; instead of mirroring a carefree mood it may be about the wish to be happy. On the other hand, it may signify the indomitable spirit, incredible strength, and endurance of a child. It may be about happiness in spite of the pain brought on by a chronic headache or it may be the excitement manifest in a child with an attention deficit disorder.

What You Will See

The forum in which the art was created is as diverse as the group of children themselves. The art was not necessarily made exclusively for *Childhood Revealed* nor with the goal of sending out a particular message. The adults who worked with these youngsters knew of our mission and sought art that best captured the child's plight. Some work was done in therapeutic settings, some was made in school programs or even at home. Shown in this format, it is admittedly out of context, removed from the telling process from which it was made.

Just as there is no "one" way of making art, there is no "one" type of child or "one" kind of picture. Even a detail in a picture can speak volumes, echoing a prescient inner angst or resource. You may be corralled into feeling the fragmented, lightning bolt lines behind a huddled figure exactly portray your own feelings of anxiety, or you may be lulled into feeling at one with the peaceful landscape painted by a young child with pervasive developmental disorder, now grown.

Certainly we all can empathize with feeling sad, or mad, or wanting a life better than the one we have. That said, still you will probably be horrified and shocked, even sickened, by the power of some images, particularly stark depictions of abuse and domination. There is nothing pretty about pain. The youngsters whose art is represented in this book share something with each other even more than they share it with those who are untouched by their predicament. Their lives accommodate challenges that are beyond the norm, things we wish could be eradicated.

The Art of a Child

Although a young person's art may not demonstrate the range of skill found in mature artists, their work can be infused with equivalent sophisticated meaning. Intensity is not a function of age or training; the untutored rendering is equally rich with its own provocations. The art in this book is a testimonial to the fact that the young can convey their feelings in all manner of creation, be it uninhibited, careful, explosive, or studied.

The customary transitory childhood dilemmas, sibling rivalry, assertion of independence, boredom of homework can be felt in the artwork. The images accompany the usual triumphs of childhood, the resolve to succeed in school, or to grow up and marry. This is what unites the children represented in this book with those we call psychologically and physically "healthy."

But for the kids represented here, achieving the usual childhood milestones and passing everyday

landmarks may not have been as easy as for their more "normal" peers. What may seem to be in common among both kinds of children is also what distinguishes them. In *Childhood Revealed* the individual effort is our focus and our concern.

Different Ages, Different Art

Many things influence how any child or adolescent makes art. The most obvious is age. Young children do not have the same physical capabilities as teens, therefore their handling of paint is never as controlled as that of adolescents. Similarly, they do not have the same cognitive maturity. Thus the young child may make something important look bigger while the older teen knows that the world has perspective, that doors and windows should be related in size. The emotional trials consuming these youngsters vary as well. While the first grader can be preoccupied with separation, the high schooler can be preoccupied with acceptance, with fitting in rather than standing out. This normal variance is reflected in the subject matter that defines a specific age. Likewise, a person's ability to handle emotions changes over time, so that the young may be more prone to act out in an uninhibited fashion while the teenager is more measured, more self-monitored. You'll find examples of these and more pictured here.

Different Art Materials, Different Art

Last, media matters. Anyone who has ever put pencil to paper knows this is conducive to making detailed images, whereas using clay provides a child with a vehicle for a less differentiated product. For the adolescent with an eating disorder, trying desperately to micromanage her world, vain attempts at perfection may best be done in collage. Here the art can look tidy, with the printed word substituting for painful internal feelings. Likewise, an astute professional may suggest or guide a youngster to a particular material precisely because it offers a certain experience. When feelings seem unformed or indistinct, the malleability of clay may be soothing or offer potential for expression. For the first grader, messy materials can result in glee or resistance, depending on the child's own struggle with burgeoning controls being amassed and necessary at this age.

The confluence of these many variables is evident when contemplating a picture that, for example, appears to be a hurriedly applied wash of color. The fluidity of paint may best convey the surprising power of a tornado and the fear it creates in a child. Just like any other art, the art in this book offers only a snapshot, an image of a child and his or her feelings captured at a moment in time. This becomes apparent when you happen upon a series of work done by one youngster. The progression and difference that is expressed is telling. It reminds us that we cannot, and should not, jump to conclusions about any one person based on a single attempt with a specific material or fleeting rendition of imagery.

How to Look at the Art

There is no right or wrong way to view this art. What does matter is your receptiveness to the images. We don't want you to think that every drawing of a skeleton is a harbinger of depression, or that all children who have trouble learning seek solace identifying with a superhero, or that anger always looks red and black. What we do not want is for you to look at this work and use it as a cookbook of symbols. Any divine mean-

ing and diagnosis are always carefully concluded by a host of professionals using multiple sources of data from the children themselves as well as from those central to their lives. We don't expect you to "analyze" or try to "diagnose" the drawings. Rather, like any form of art, the most important condition we ask of you is to allow yourself to respond openly and without prejudgment. Certainly, some of the art may resonate with parts of you that are obvious, other art may touch emotions that are long buried or dormant or unnoticed. It is your job to attend to what the art is saying. Each of you is entitled to your singular response.

Art That Reveals

Children and art making and personality are complicated topics by themselves. Taken together, they are formidable. Each piece of art reflects multiple influences and should not be viewed solely as the result of a given disorder or condition. We are fully aware of the difficulty and seemingly arbitrary nature of putting the art into different diagnostic, social, and physical groups. We realize the irony of having the art in categories and then asking you not to categorize. Certainly many of the youngsters had more than one "diagnosis," and their art could have been shown in many different sections. However, diagnosis becomes a way to make sense out of something that may seem inchoate. It gives professionals and parents a method for sorting out what can and needs to be done to offer a child the best life possible and a chance to live up to a potential that should be realized rather than stalled. We have done our best to be sensitive to the criticism about "labeling" individuals; it's just this sort of categorization that can inadvertently brand a child for life. As professionals and responsible human beings, we've tried to respect the youngster's innermost feelings.

What is clear and unambiguous is that all of the young artists seen here have something to tell us. It is through them that we want to remove any shame about a label or description.

Use What You Learn

We all know that children communicate in different ways. They use language and action and play and art. The children who bravely reveal themselves to you here want you to use what they have told you. We hope you will be moved, amused, and enriched by looking at the art. We also hope it will make you ask questions —of yourself and, if you are a parent, of your children.

If you find that something is troubling or disturbing we want you to find out more about it or ask someone for help. You can utilize the reference lists we have provided at the back of this book or you can ask help of your child's teacher or seek out the appropriate professional. You should check out your perceptions with your spouse or close friend, ask your pediatrician for an opinion, talk directly to your child, and do not end a discussion until you are satisfied that your worries have been calmed.

Parents are often the first and best line of defense when it comes to ferreting out a problem and battling what can be unwelcome questions. Perseverance can mean the difference between letting something go by and helping a child thrive. If something you see is pleasurable, we hope you realize that regardless of the challenge any of these youngsters face, their life is not without joy. We are committed to believing that the spirit born in children can be transmitted by virtue of its being acknowledged in their art. As these youngsters strive to soar beyond what many might expect, they move toward what we hope for each of them. While they navigate childhood we hope they continue to forge their own creative and unique paths.

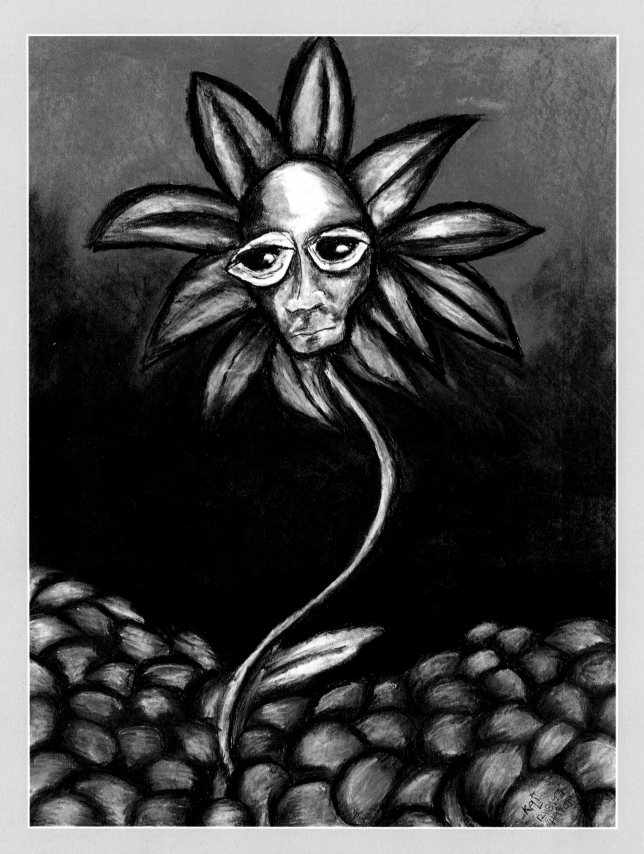

Female, 16 years old. **Heroin,** 1997/8. Conte crayon & charcoal, 24 x 18"

The circles are like rocks . . . cold and dead. One beautiful thing grows
out of the deadness, which shows there is still life. It shows how beautiful
things can come out of deadness. That's how heroin is. It's the pretty part,
but it can also be the deadness. It's depression.

Depression
When the Blues Won't Go Away

The following words by the Greek poet Epictetus have been a great source of comfort and guidance for me.

"Ask not that events should happen as you will, but let your will be that events should happen and you will have peace." These words are important to me because they mean we can't control what happens in life, but what we can control is the way we look at it and the way we allow it to affect our mental health outlook.

Deborah Norville, Anchor, *Inside Edition*

ANDY, ELEVEN, DOESN'T KNOW WHAT'S WRONG. HE CAN'T SEEM TO GET OUT OF BED IN THE MORNING, often has trouble falling asleep at night, and nothing his parents do or say can lift his lethargy. "It could be a perfect spring day," says Andy's mother, "but he's not interested in joining the other kids playing outside." Andy doesn't even care to see his two best friends, and when they call, he tells his mom he has a stomachache or a headache—again. He's no longer excited about hockey, though last year he was the team's highest scorer. In fact, most of the time Andy feels like crying, but he's careful not to let anyone know because he doesn't want to worry his parents. They've had enough on their minds, he figures, since his dad lost his job last year. Though the pediatrician has ruled out any physical illness, Andy has no appetite and he's as skinny as his seven-year-old sister. Recently, when a teacher tried to coax a smile out of him, Andy burst into deep, heaving sobs, so uncontrollable that his mother had to come to school and take him home. "I just feel like a piece of me inside is missing," was all he could say.

Everything bothers fourteen-year-old Stephanie. "She wakes up in the morning mad at the world," reports her mother. "We can't have a conversation without her sneering and snapping." Stephanie has always been a demanding, high-maintenance child, but in the past year her impatience, negativity, and defiance—especially at home—have worsened. At first, her parents chalked up the sullen attitude and the slammed doors to typical teenage turmoil, but they're getting increasingly worried. Always a top student, Stephanie now rarely opens a book and spends her afternoons and evenings locked in her room, refusing to tell her parents what's bothering her. "I feel terribly guilty saying this," admits her mother, "but in a way, I'm a little relieved. So much of the time I can't stand to be around her." Stephanie's father agrees: "I think it's high time she just snapped out of this and started taking some responsibility around here."

The trouble is, neither Andy nor Stephanie *can* snap out of it. Though their symptoms are different, Andy and Stephanie both suffer from *Major Depressive Disorder*. It's not surprising that neither child's parents realized what was causing their offspring's problems. Even today,

depression in children often goes unrecognized and, as a result, untreated. In fact, until 1980 the psychiatric community had no official set of diagnostic criteria for this disorder, since doctors and lay people believed that emotional upsets in children were fleeting and shouldn't be taken too seriously. Conventional wisdom held that children couldn't be depressed because they hadn't experienced enough of life.

Now we know that children have no such immunity. As a disorder, depression is rare in youngsters under twelve, affecting just 1 to 2 percent of children five to eleven years old, boys and girls equally; children age two or three years old may also display symptoms of depression. Youngsters *show* signs of depression, ranging from a handful of symptoms to full-blown psychosis. By the time they hit puberty, an estimated 8 percent of young people twelve to eighteen (nearly twice as many girls than boys) suffer from major depressive disorder, a spiraling sadness so deep the gloom never leaves. But depression in children, as in adults, has no one face. Like grown-ups, youngsters may display an array of seemingly contradictory symptoms. They may be quiet, lethargic, and withdrawn, or irritable, belligerent, and angry. Or they may have a sudden change in behavior and attitude that appears to come out of the blue. But they share a common denominator: unshakable feelings of helplessness and hopelessness rob their lives of joy and they may become so self-critical that they contemplate—or even try—to kill themselves.

An Elusive Diagnosis

Depression in children is notoriously difficult to diagnose for many reasons, not the least of which is the fact that the word is bandied around so frequently and arbitrarily. After all, everyone gets "depressed" at one time or another: When we gain five pounds and can't lose them; when we fail to get the job we want. Even kids use the term colloquially: "I got a C on the history midterm—I'm so depressed," your high school sophomore might say. However, when doctors use the term, they mean more than a temporary sadness or disappointment. Clinical depression is a constellation of symptoms that occurs over a specific period of time; has a definite onset, duration, and ending; and impairs a child in some profound way.

Contributing to the elusiveness of the diagnosis is the variety of factors. Some youngsters suffer from what's known as dysthymia, or minor depression, a kind of low-grade sadness that lingers for months or years. Quiet and shy, they may be dubbed "good" children, when in fact they are depressed. Conversely, an aggressive youngster, summoned daily to the principal's office for punching his classmates, may be labeled a behavior problem and disciplined more harshly, when what he really needs is help to combat depression.

Further compounding the difficulty is the fact that depressed kids often struggle with other problems—anxiety, eating or conduct disorders, learning disabilities, or bipolar depressive disorder—that must be ruled out before a definitive diagnosis can be made.

When Kids Are Sad—and Mad

Why is one child emotionally resilient while others buckle under the first setback? Just as there's no one cause of depression in adults, a combination of factors—some genetic, some social—can trigger depression in young people, and they're all exacerbated by stress, particularly during the teen years. Studies reveal a strong family link, most likely an inherited abnormality in brain chemistry, that makes a person more vulnerable to the illness. Children of depressed parents have a higher risk of developing depression, recover more slowly from depressive episodes, and are more likely to have a recurrence. However, a depressed child can't simply "buck up" and will away his or her depression. Indeed, too often we waste valuable time and psychic energy wondering what causes depression when we could be treating it.

Still, for parents the diagnosis is a harsh blow, and they may continue to deny it out of guilt and fear. In fact, depression is not only no one's fault, it's highly treatable, the sooner the better. Even mild episodes of childhood depression can be harbingers of more serious problems later. Doctors now use a combination of psychotherapies—including play, behavior, and cognitive therapy in individual or family counseling—as well as medication to help depressed kids regain control of their own lives.

The Warning Signs

If your child has one or several of the symptoms listed below, it doesn't mean he or she has a serious problem, but it *does* mean you need to trust your instincts and consult a doctor. The following are useful clues:

Depressed or irritable mood most of the day, most of the time

Lack of interest or pleasure in activities previously enjoyed

A significant weight loss or gain; change in eating patterns

Inability to concentrate or focus on work or other activities

Feelings of worthlessness, hopelessness, and guilt

Continued agitation, sluggishness, or fatigue

Inability to fall or stay asleep

Recurring thoughts of death or suicide; increase in risk-taking behaviors

Depressed kids see the world through cracked glasses. By learning about depression and pushing to get the answers you need, you can help your child put his life, and his future, into better perspective.

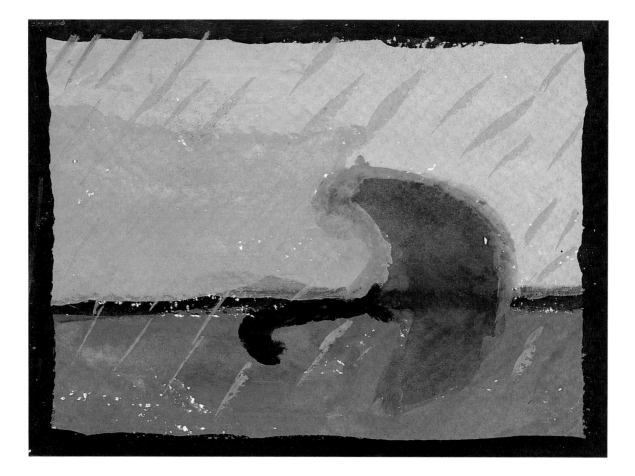

Female, 14 years old. **Untitled**, 1993. Watercolor, 4½ x 5¾"

I remember it was raining. We were in Portland. Mom had thrown a knife and I saw her using cocaine with her friend. Seeing the painting now reminds me of how lost in the "rain" I really was. When I think back now to how I felt and dealt with the obstacles thrown in my path . . . thank you for helping me when I felt life was burying me alive.

What scares me most...

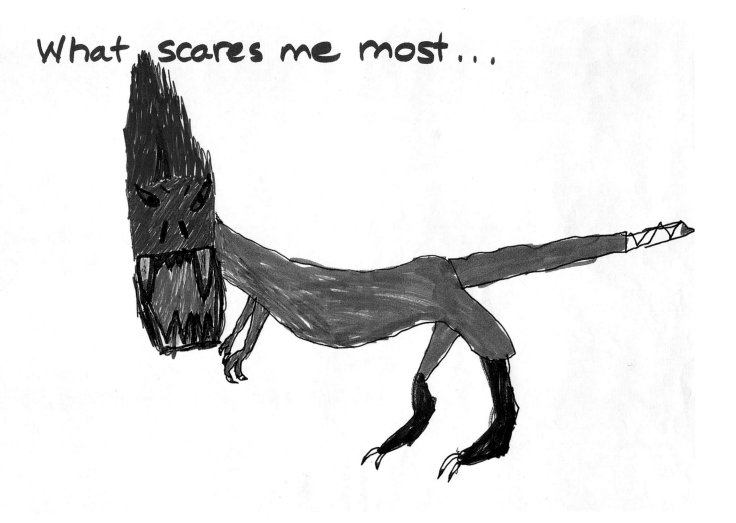

Male, 10 years old. **What Scares Me Most,** 1998. Felt markers, 12 x 17"

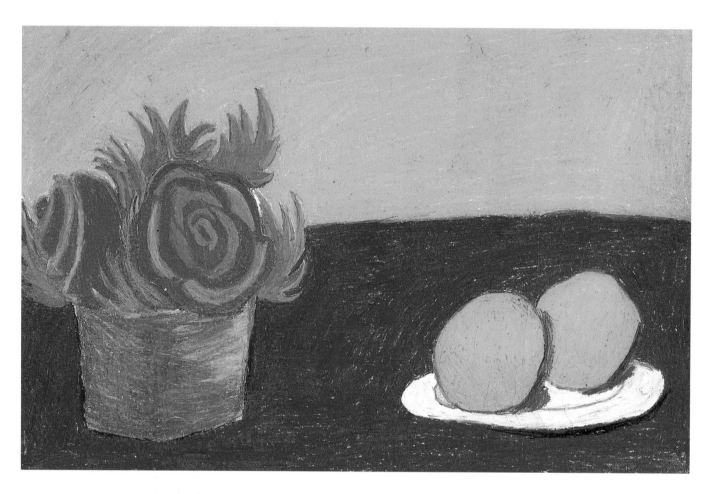

Female, 16 years old. **My Future Apartment,** 1998. Oil pastel, 12 x 18"

This still life drawing was created from my imagination.
It represents what will be in my future apartment's dining room table.
I like this drawing because it's colorful and I like looking at it.

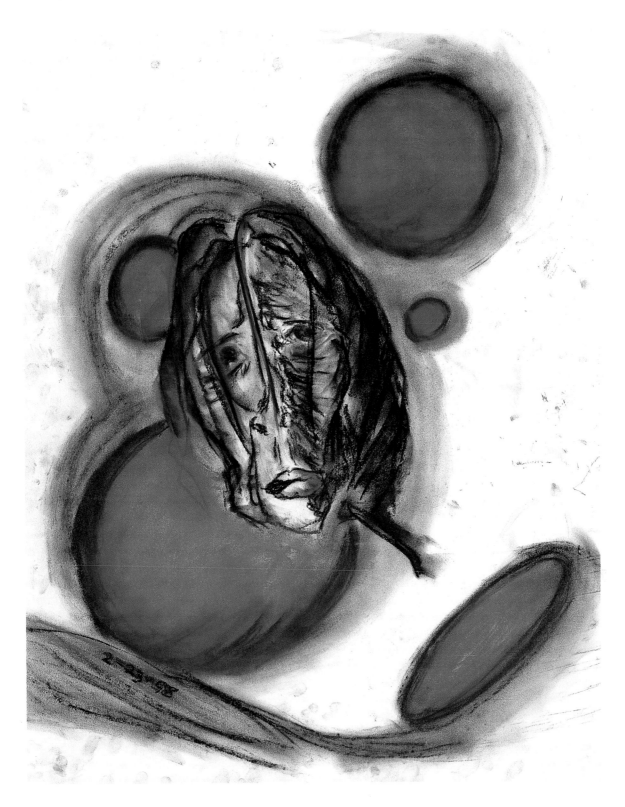

Female, 18 years old. **Misery,** 1998. Pastel, 24 x 18"

Female, 18 years old. **Melancholy,** 1998. Pastel, 18 x 24"

Male, 16 years old. **Untitled,** 1994. Oil, 20 x 16"

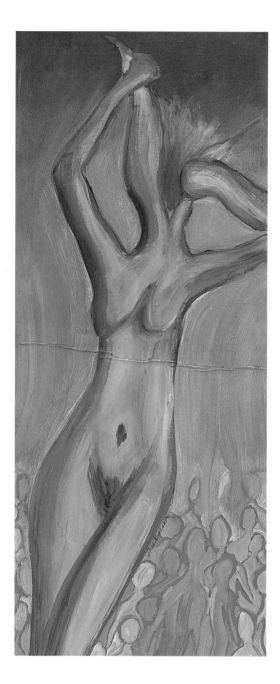

Female, 18 years old. **Hatred of the Flesh,** 1997.
Oil on mat board, 16 x 5½"

One looks up and suddenly finds
themselves smothered by a sea of
others—exactly the same. One awakens
to find themselves living under a
multitude of rules that make no sense
and bear no meaning. Finally, one
decides to escape and with all the rage
building inside one finds the strength
to soar above and tear off the skin of
humanity that weighs us down.

Male, 18 years old.
Constricting Flow, 1997/8.
Silk painting, 54 x 8½"

This silk scarf repre-
sents the development
of my depression over a
long period of time.
Depicts the many paths
I had to choose from and
the colors represent
hopefulness.

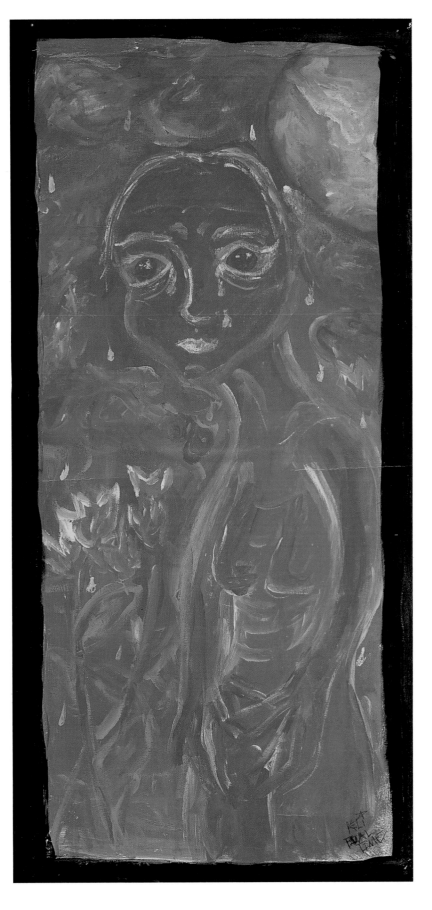

Female, 16 years old. **Time,** 1997/8.
Acrylic, 38 x 18"

Depression. It's one shade of a color. It
feels. Doing the art helped. I was really
depressed and hadn't done anything or
painted for a long time. There's flowers,
symbolizing happiness and hope that I
still hang on to when I'm depressed.
When finished with it, I feel better, like
I had forgotten all my yucky feelings.

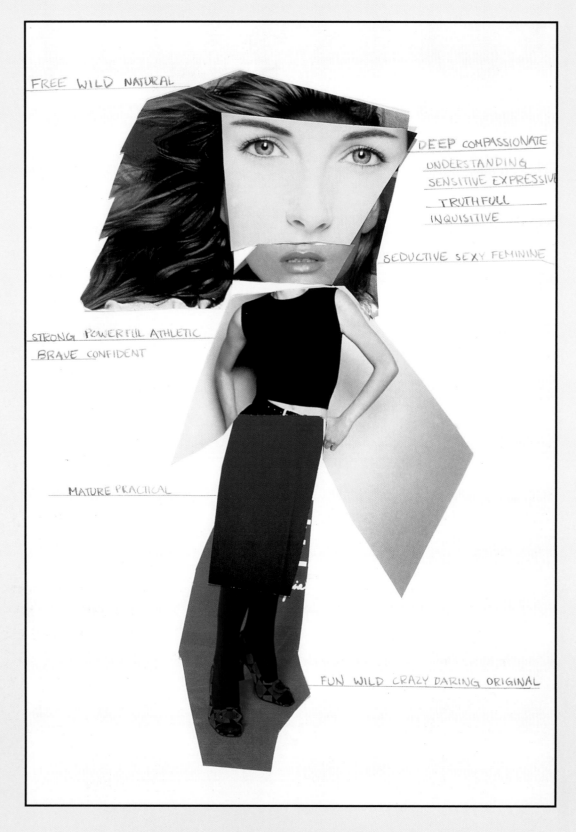

Female, 15 years old. **Image,** 1998. Mixed media, 20 x 10"

The ideal woman balances many traits to create her image. Each woman holds her own variation of this perfect person in her mind. We guide our actions and reactions to emulate this concrete picture we have admired. However, the question of her existence remains undetermined. Can any individual carry all of these characteristics?

Eating Disorders
Dying to Be Thin

CARRIE, SIXTEEN, LOVED BEING TALL AND THIN. A STAR OF HER HIGH SCHOOL CROSS-COUNTRY track team, her reedlike shape was an asset since she could run faster and jump higher than her friends. But the summer between sophomore and junior years, Carrie gained fifteen pounds—and every glance in the mirror triggered waves of disgust. Pulling on an oversized black sweatshirt, she vowed to try the diet that her best friend Tracy had told her about. But no matter how little the girls ate—often nothing more than a few dry lettuce leaves at dinner—neither was able to get down to what was, in their minds, an acceptable weight. That's when they made a pact. Several times a week, for three months, they met to binge on the foods they loved—and then forced themselves to throw up. Though her parents grew increasingly alarmed at her weight loss, Carrie insisted it was because she was running more to get in shape for the spring track meets.

For a time, the binging worked. But soon Carrie started to think she wasn't thin enough and she switched from binging and purging to gobbling laxatives like candy. "Tracy and I were in this together," Carrie recalls. "We were competitive on the track field and competitive in the classroom. We both wanted to be number one. We bonded over eating—and no one else ever knew."

At least not until Carrie, who had dropped to eighty-eight pounds on her five-foot-four-inch frame, collapsed in gym class and was rushed to the hospital suffering from a pituitary gland imbalance. Her hair had started to fall out, she had stopped menstruating, and she was so thin you could easily wrap your fingers around her waist. Had it not been for the intervention of medical specialists, Carrie would have died of self-starvation.

The Pressure to Be Thin

Rare is the preteen or adolescent who is not concerned about the way she looks. Thighs are inevitably too big, ears stick out too far, hair is too curly or too straight. But for some, the concern over how their bodies look becomes an obsession, one they bear with shame yet cannot break.

In a society preoccupied with weight, where calories are carefully counted and percentages of body fat analyzed, one needs only to flick on the television or open a magazine to be bombarded with images of svelte models, news from the latest diet guru, or warnings about eating too much fat, too much sugar, too many carbohydrates, or too much of whatever the latest weight-loss scheme mandates. Combine these influences with the pressure to perform in school

and win friends and for many youngsters *not* eating becomes a moral decision. The message is not so subtle: gaining weight is not just bad, it's a sign of personal weakness. To be fat is to be undesirable — and unlovable.

Twenty years ago, many doctors completed four years of medical school without ever seeing a case of *Anorexia Nervosa* (self-starvation), *Bulimia Nervosa* (binge eating and purging), or *Binge Eating Disorder* (recurrent episodes of binge eating, followed by periods of guilt and disgust, usually in highly overweight youngsters), the most common examples of disordered eating. Study after study reveals an alarming upswing in eating disorders, with an estimated 3 to 5 percent of adolescent girls suffering from a diagnosable eating disorder. More troubling is that, at any given time, two-thirds of teenage girls — most of whom are already at a perfectly normal weight for their height — are busy dieting anyway. And they're starting at ever younger ages. It's not unusual, experts say, to hear nine-year-olds complain that their stomachs stick out too much or to request that their mothers buy them nonfat yogurt. Gender is becoming less a factor. Eating disorders, long considered a "woman's disease" affecting primarily young white females from middle- and upper-middle-class homes, are now gaining recognition as an equal-opportunity illness. Boys comprise roughly 5 to 10 percent of patients with anorexia nervosa and bulimia nervosa, and about 4 percent of patients with binge eating disorder.

Disordered eating covers a wide range of attitudes and behaviors about food — the compulsion to exercise frantically; regularly induced vomiting after meals; the taking of water or diet pills; gradual starvation by not eating at all — that become the major focus of a child's life. These are youngsters who take no enjoyment in what they eat. Rather, they are tormented by food, often terrified to put anything in their mouths, yet ashamed of their purging habits. Somewhere along the way food becomes inextricably linked to self-image and confidence. The distinction between how children look and who they are blurs.

Typically, eating disorders peak around puberty, when a girl's body begins to change and academic and social pressures increase, as well as at age seventeen or eighteen, when a teenager first leaves home for college. Youngsters who participate in gymnastics, ballet, or other sports that prize thinness may be particularly at risk. Some girls are so distraught by their new womanly curves that they believe starvation is the only option to change their looks. The problem usually starts innocently enough, with a girl's desire to lose a pound or two; unchecked, it can steadily worsen. One-third of all cases last five to ten years. Once disordered eating veers into a diagnosable eating disorder, a child is at risk for serious medical problems — stunted growth, the cessation of menstruation, even heart problems. In fact, anorexia and bulimia have the highest death rate — about 5 to 10 percent — of any childhood psychiatric illness.

But cultural pressures are only part of the eating disorders story. Children who are at risk for this illness often present a complex combination of factors—some genetic, some part of other psychological problems, including depression, anxiety, even sexual abuse unbeknownst to parents. Not surprisingly, the disorder can result from pressure to meet high standards set by overachieving parents. Children with eating disorders often come from homes where one or both parents are overcritical or rejecting, or where food and dieting are central parental concerns. Conversely, some parents may use food as a token of love and appreciation, triggering power struggles with susceptible children that lead to an eating disorder later on.

Then, too, while environmental factors play a key role in eating disorders, so does temperament. Children who are perfectionists, inflexible, or easily paralyzed by a sense of inadequacy or helplessness, are susceptible. When life feels out of control—as it does for many preteens and adolescents—eating becomes the one thing they can control.

What Parents Can Do

While parents may inadvertently play a role in the development of a child's eating disorder, the good news is that they can help a child overcome or even prevent illness in the first place.

Accept the way you look—at least in front of your child. Avoid making disparaging remarks about your own body, even in jest. (How many times have you struggled into a tight pair of jeans and mumbled, "Oh, I'm so fat!") If you worried about your weight when you were a teen, consider whether you're unconsciously passing along anxieties about body image to your children.

Stifle criticisms of your child's weight. Remember—and remind your child—that every-body is different, and every body develops at different rates. Teach your daughter that it's normal for girls to put on weight in their thighs, rear, and hips to help them conceive and carry a healthy baby to term. Encourage your child to eat a well-balanced, nutritious diet and to exercise regularly so that she'll have a healthy body, not a glamorously shaped one. Listen to your child and her friends when they talk so you can counter erroneous media images with realistic ones.

Never use food as a reward or a punishment and don't bribe a child to eat more. If you're concerned about your child's weight, consult your pediatrician; if the doctor assures you that your child is healthy, rest assured. When you make food a big issue—whether it's

eating too much or too little — you set the stage for a power struggle that can be tough to break. By restricting what a child can eat, you make her want it even more. Children need to trust their own instincts and recognize when they are really hungry instead of when they're angry, frustrated, anxious, or bored.

Let your daughter know that you are proud of her as a person, not just of the way she looks. Take her interests, talents, and passions seriously.

As often as possible, eat together as a family and share what's going on in your life, as well as your feelings about it. One of the key weapons in the fight against eating disorders is an intimacy between parent and child. When she knows she can come to you if she's upset, you're heading in the right direction.

If you notice radical changes in your child's weight or eating habits, consult your primary care physician or an eating disorders specialist. Children with eating disorders can be helped and cured. In counseling, both individual and family therapy, perhaps in conjunction with medication to combat depression, children learn how to manage food in a healthy way and to feel better about themselves no matter what their size or shape.

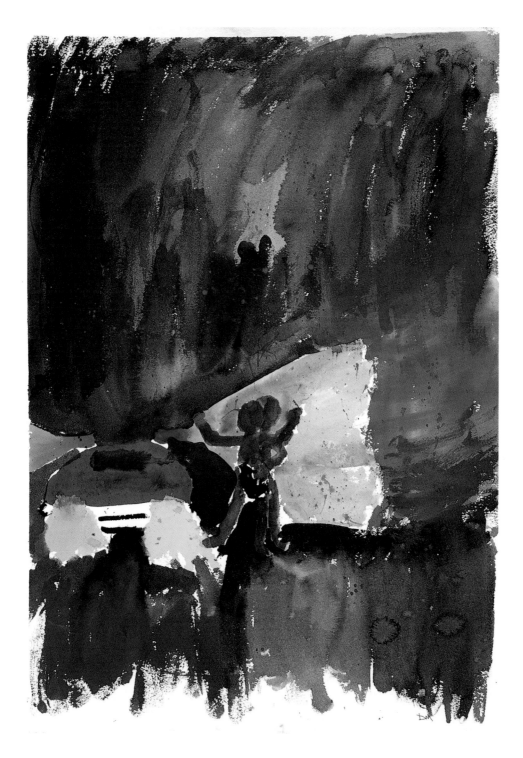

Female, 17 years old. **Untitled,** 1998. Watercolor, 24 x 18"

Not knowing the meaning of what I was painting, I ended up with
this—two figures trapped in a flood of red and blue light with nowhere
to run to. I may be one of them, the one caught redhanded. Maybe it
was not my idea but I went along with another. Or maybe these are
the two sides to me, the one that wants to do what is right and
the one that is sick of always doing what she is told.

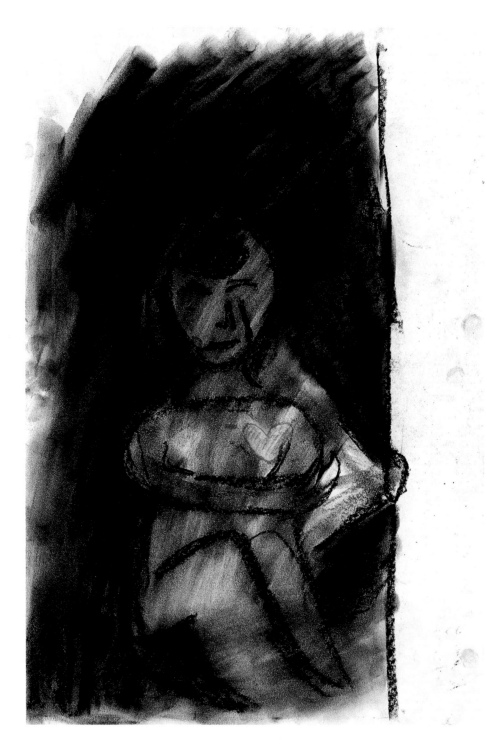

Female, 16 years old. **Untitled,** 1998. Pastel, 18 x 12"

I did this when I was feeling really sad and confused about my self-image.
I felt that "I" was "bad" but that my heart was "good."

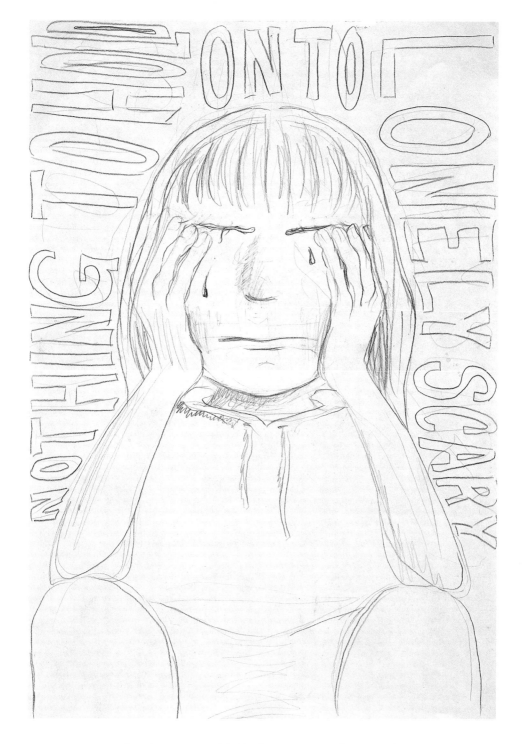

Female, 15 years old. **Shadow,** 1998. Pencil, 20 x 10"

Depression surrounds you like a thick cloud. It shouts ugly truths and
persuades you to believe even harsher falsehoods. You cannot hide from
depression. It haunts you every second of the day. It refuses to leave
your side yet in its presence, you are alone.

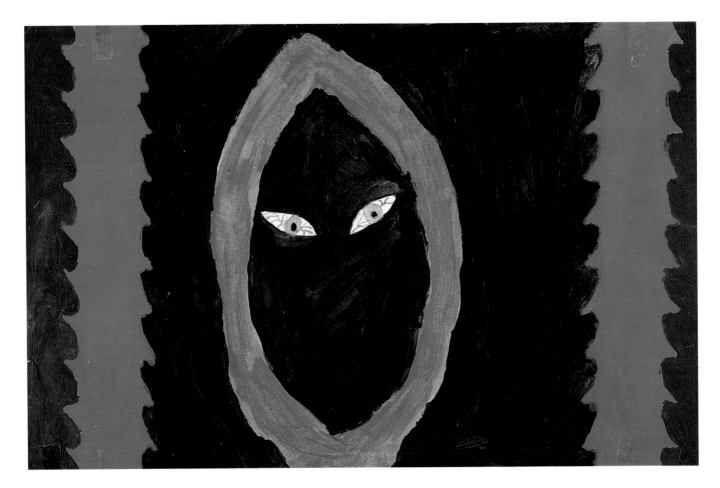

Female, 16 years old. **Untitled,** 1998. Tempera, 12 x 18"

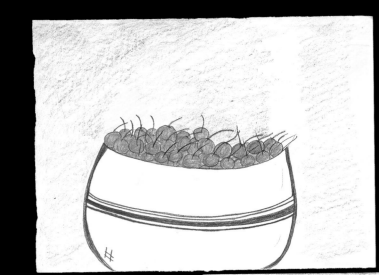

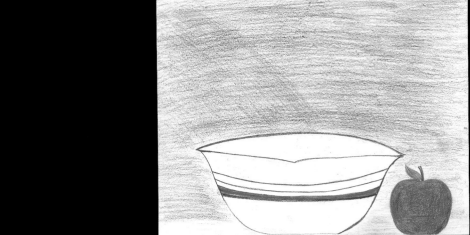

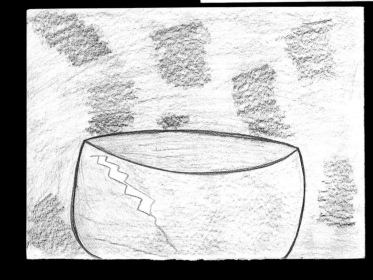

Female, 17 years old.
Perception: two Extremes and the Middle, No.1, 1998. Mixed media, 30 x 17"

The bowl of cherries represents the picture I show the world: strong, sweet, and perfect. The cracked empty bowl is how I see myself: damaged, lonely, discontent, and imperfect. The empty bowl with fruit next to it represents how I would like the world to see me and how I would like to feel about myself: safe, beautiful, and healthy.

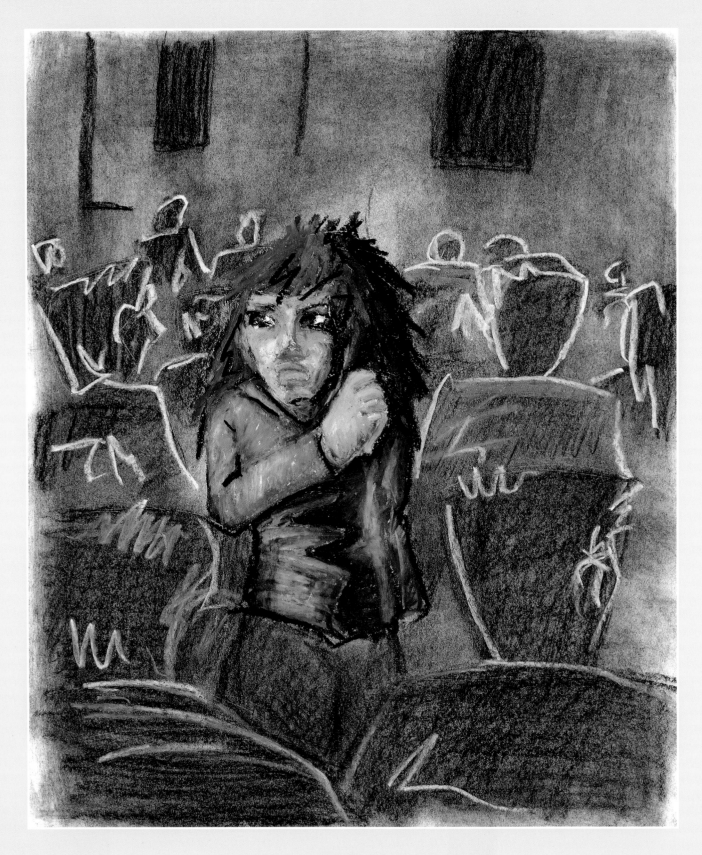

Female, 18 years old. **Truth,** 1998. Oil pastel, 14 x 11"

This represents what I feel whenever I have a strong emotion, anger, hurt, injury or attraction, etc. Whenever I feel this way I automatically make sure it doesn't show. I have fears that showing my emotions will make me vulnerable or that I will hurt someone and regret it later.

Anxiety Disorders
Worried Sick

EVERY MORNING, SIX-YEAR-OLD MOLLY WAKES WITH A GRINDING PAIN IN HER STOMACH AND A pounding in her temples. Some days her chest is so tight she can hardly breathe. Her parents must brace for the inevitable tears and tantrums as they try to get her dressed, out of the house, and onto the school bus. Though she's always had a difficult time separating from her mother, this year Molly's been absent from school more days than she's been present. "What if the bus driver forgets about me?" Molly tearfully wonders. "What if I can't find the bathroom?" Sadly, nothing her parents say or do calms her.

For Alex, seven, a simple homework assignment—like copying ten spelling words into his notebook—becomes an agonizing ordeal. He worries that his penmanship isn't good enough and crumpled sheets of paper, evidence of his nightly conflict, litter the bedroom. Though intelligent and precociously articulate, Alex rarely speaks in class, never volunteers for special projects, and spends most of recess by himself. He even refuses to sign up for Little League because he "just knows" he's not as good as the other kids.

Long after her parents think she's sound asleep, Jenny, twelve, tiptoes out of bed and begins her nightly routine. First she checks under the bed, then under her desk and inside her closet, from top to bottom. She checks the windows and front door to make sure each is securely locked, then looks inside the kitchen cabinets. Then she does it all over again, "because maybe, when I wasn't looking, someone snuck inside. I know it's crazy," says this straight-A student, "but I can't help it. My head is filled with all these thoughts. And I'm scared that if I don't do all these things, something bad will happen to me or someone I love."

At one time or another, all children are swamped by worries or fears. They may be afraid of monsters under the bed, thunderstorms, dogs, or water. They may fret that they'll fail an important test, that no one will like them, or that they'll embarrass themselves on the soccer field. Yet for some children—like Molly, Alex, and Jenny—the fears and worries don't go away. These youngsters aren't just "going through a phase." They suffer from an *Anxiety Disorder,* the most common mental health problem in childhood, affecting an estimated 5 to 20 percent of youngsters. For them, worries and fears are so crippling that daily life—at school, with friends, at home—is light years away from the idyllic picture of childhood that most of us cherish. A child

with an anxiety disorder feels shaky, frightened, and often hopeless. Such children tend not to like themselves very much and often feel rejected, neglected, and alone.

Anxiety disorder is an umbrella term that actually encompasses several psychiatric conditions, among them *Separation Anxiety Disorder* (the fear of being alone or separated); *Generalized Anxiety Disorder* (chronic, intense worrying); *Social Phobia* (extreme fear of social situations or any experience in which performance is judged); *Obsessive Compulsive Disorder* (in which involuntary thoughts or impulses cause a child to repeat ritualized behaviors).

These disorders may frequently overlap with other psychiatric problems. Youngsters may also be depressed, or may exhibit aggressive, disruptive behavior in school or with friends. They may complain of a host of symptoms—diarrhea, stomach pain, sleeplessness, jitteriness, loss of appetite, fatigue—and yet a battery of tests and sophisticated medical procedures will fail to pinpoint an organic cause.

Ironically, a child's anxiety disorder may be overlooked, not because parents or teachers don't care about his well-being but simply because he seems otherwise so conscientious and precocious. If, for example, Jessica is worried about passing her history midterm, she'll most likely study especially hard for it. If she's so afraid to say what's on her mind, she may be viewed—incorrectly—as a perfectly cooperative little girl. To a certain extent, worrying keeps a child safe. A reasonable fear of strangers or of abusing alcohol, cigarettes, and drugs can prevent her from taking inappropriate, dangerous risks.

When Does a Worry Become Worrisome?

It's important to remember that anxiety is a perfectly normal emotional state. Certain fears are typical of certain ages: nine-month-old babies are frequently afraid of strangers; preschoolers fear the dark or big dogs; and ten-year-olds may worry about kidnappings, holes in the ozone layer, or anything else they overhear on the nightly news. But for a child with an anxiety disorder, the fear or worry is so intense, she's unable to calm herself. And it persists well beyond the period of time we expect her to grow out of it.

Experts use four key criteria in determining whether a child might be suffering from an anxiety disorder:

Duration
How long has the child had this problem? Is she having a bad day—or has she been behaving this way for weeks?

Age appropriateness
A two-year-old who wraps herself around Mom's knees during the first few weeks of school is behaving normally. A nine-year-old who acts this way is not.

Intensity

To what extent is the behavior disrupting her daily life? Is your three-year-old so ter-rified of monsters that she can't fall asleep night after night, despite your reassurances? Does your fourteen-year-old worry so much about final exams that she blanks out in the middle of the test and is unable to finish? Then that anxiety must be addressed immediately. Anxiety disorders wreak havoc in families and they are frequently the harbinger of more severe problems (such as depression, alcohol and drug abuse, or even attempted suicide) later on.

Intractablity of the problem

In other words, despite experience and the passing of time, is the child still maintain-ing a high degree of anxiety?

Nature or Nurture?

For years, conventional wisdom held that a child's psychiatric problems were triggered by either a traumatic experience or poor parenting, or sometimes both. But in the past three decades, as scientists have learned more about the structure and functioning of the brain, they've discov-ered that these conditions can be triggered by a genetically linked imbalance of brain chemicals called neurotransmitters. That means some children may be born with a predisposition to develop an anxiety disorder. Still, though some kids are temperamentally hyper-vigilant and anxious, environment plays a role, too. Anxiety and fear reactions can be learned, through direct experi-ence or by observing others. In fact, anxiety runs in families—anxious parents may inadvertently raise anxious kids.

Nevertheless, the key to helping a child with an anxiety disorder is not to dwell on what might have caused the problem but rather to ask what can be done now to help him or her over-come it. Anxiety disorders may be among the most common childhood psychiatric problems, but they are also the most treatable—and in a relatively short time. Indeed, most children respond well to cognitive behavioral therapy—sometimes in conjunction with medication—and fre-quently in tandem with their parents and other family members. They can be systematically taught to confront their worst fears and forge a realistic coping plan. With gradual exposure to the sit-uations that frighten them, and by teaching them the skills necessary to relax when they do feel anxious, they can lower their stress levels and leap the hurdles that had previously loomed so large. Most important, the skills learned in cognitive behavioral therapy can be used to meet and master whatever challenges, or curveballs, life throws their way.

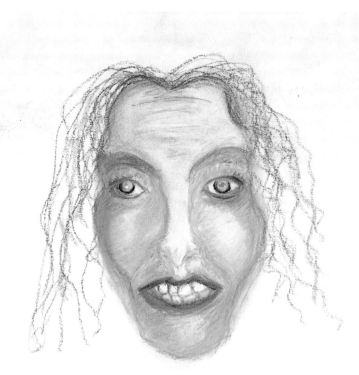

Male, 16 years old. **Self-Portrait,** 1993. Pastel, 12 x 12"

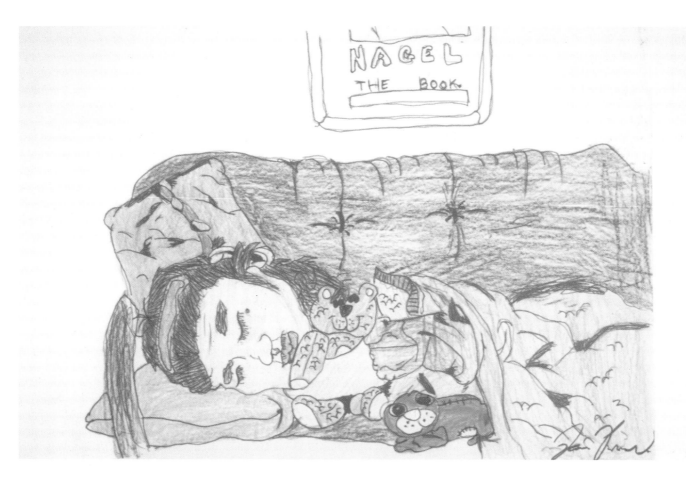

Male, 10 years old. **Christina and Her Pink Blanket,** 1997. Colored pencil, 8½ x 11"

Art keeps me out of trouble. I drew her (my sister) because this is the first time I've seen
her sleeping like this, snuggled up with all her little stuffed friends. She looked so peaceful.
And when she is asleep I have no one to argue with. I made her feel happy in this picture,
it's a reflection of how I feel. I also feel happy when I'm drawing.

Female, 14 years old. **Untitled,** 1998. Mixed media, 15 x 20"

Female, 17 years old. **My Bright Circles,** 1996. Acrylic, 8 x 5½'

My bright circles are about me and how I'm surviving my illness.
The bigger the circles get is the better I am doing.
Life's a never-ending circle and I just hope to live through it.

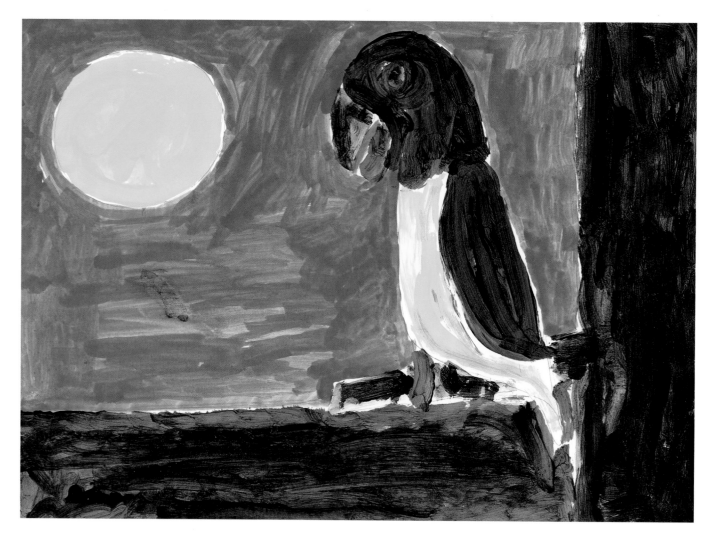

Female, 17 years old. **A Parrot,** 1998. Acrylic, 18 x 24"

My bird is sitting peacefully on a branch of the tree. I have a bird at home.

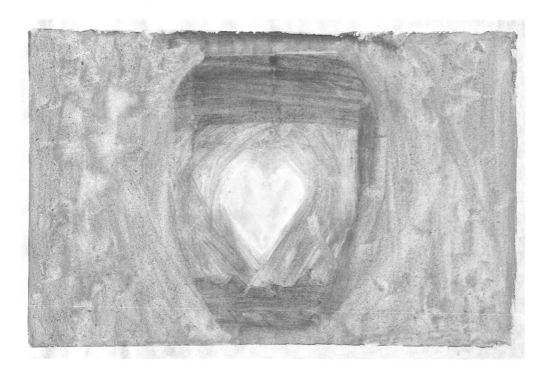

It is sort of like a color chart—dark, lighter, lights and lightest. Different colors put into one. Like colors gathering together like blue and yellow gathering together. The moon over the ocean with big trees on both sides. You could actually walk into this painting and find a beach.

Female, 8 years old. **The Ocean of Green,** 1997. Watercolor, 12 x 18"

I was playing with the light switch in the dining room. Somebody yelled fire. Luckily I was very close to the door so I just rushed out. I remember standing in the driveway thinking was this a prank because we couldn't see the fire. It was in the basement. I was 3 years old at the time.

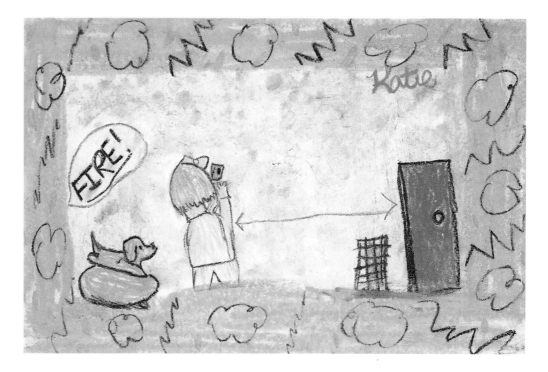

Female, 8 years old. **My House On Fire,** 1997. Chalk, 12 x 18"

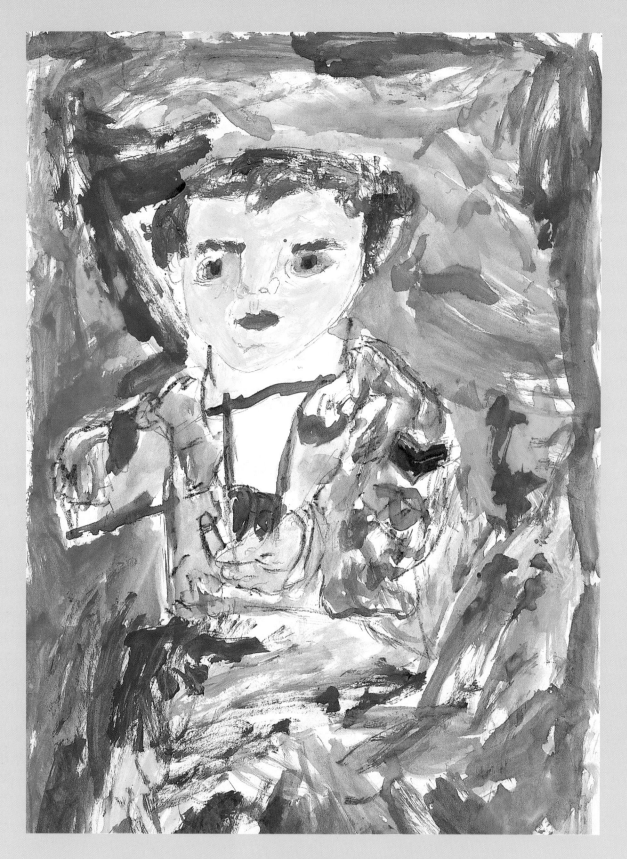

Bipolar disorder. Male, 11 years old. **Self-Portrait,** 1998. Watercolor, 14 x 11"

Psychosis
Living in a Parallel World—Children with Bipolar Disorder and Schizophrenia

A sad fact about the mental health movement is the large number of people who refuse to admit something may be wrong, refuse to learn all they can about their ailment, and who therefore fail to avail themselves of the vast amount of help that is out there.

Dick Cavett, Television Personality

IN FAMILY PHOTOGRAPHS, NELLIE IS INEVITABLY THE ONE POSING AWKWARDLY IN THE BACK corner of the picture, slightly apart from everyone else and lost in a melancholy haze. Yet in between what everyone called her "blue periods," Nellie displayed astonishing bursts of energy and imagination, during which she'd spend hours in her room creating intricate, brilliantly colored oil paintings and pen-and-ink sketches.

Shortly after her fifteenth birthday, Nellie became uncharacteristically silly, giddy, noisy, and sometimes disruptive or verbally abusive to her parents and friends. Gone was the shy girl and in her place a boastful young woman who described herself as an artistic genius, whose work was currently on display at hundreds of major museums around the world. Rattling off a string of cities she claimed to have recently visited—and speaking so fast as to be nearly unintelligible— Nellie explained that her agent handled all the details of her around-the-world appearances.

By contrast, consider eighteen-year-old Ed, who managed to elude most of childhood's ups and downs. He always did well in school and on the athletic field, and was surrounded by friends. In high school, he had been captain of the soccer team and yearbook editor; it was assumed that he was destined for a brilliant medical career, just like his father. But during his freshman year at a prestigious university, Ed suffered what his parents at first thought was a nervous breakdown due to the stress of being in such a high-pressured environment. Ed refused to leave his dorm room, convinced that Martians were beaming him cryptic, encoded messages. And every time a red car drove down the street in front of the dorm, Ed considered it proof that he was right.

Nellie has *Bipolar Disorder* (what used to be known as *Manic Depression*) and Ed has *Schizophrenia,* two very serious mental illnesses, which, though different, share one particularly confusing and disturbing symptom: repeated episodes of psychotic behavior.

Psychosis is a general term used to describe a state in which a person is unable to distinguish between fantasy and reality. When people have a psychotic reaction, they are unable to make sense of their world because their brain isn't properly processing the information it's

receiving. They may have *delusions*—ideas that are very real to them but have no basis in reality, such as Nellie's insistence that she's a famous artist, or Ed's belief that Martians implanted electrodes in his brain. Or, they may *hallucinate,* that is, they may see, hear, or feel something even though these stimuli are absent, and over which they have no control. Hearing someone give you commands, even though you are alone, seeing lights flashing when the room is dark, or feeling bugs crawl on your leg are all examples of hallucinations. A diagnosis of psychosis also may be determined by what doctors call *negative symptoms*—apathy, lethargy, and withdrawal, perhaps sitting for hours staring at a wall, unable or unwilling to make social contact.

Psychosis may be due to many factors. Psychotic symptoms may be temporarily induced by drugs, such as cocaine, heroin, or steroids. Psychotic reactions may also result from high fever or an illness such as meningitis, a brain tumor, kidney failure, or, in rare cases, extreme stress or trauma. However, once the drug's toxicity wears off, the physical illness is cured, or the stressful situation abates, this type of psychosis disappears.

But for some children, like Nellie and Ed, psychosis is triggered by a congenital, often inherited, biochemical and structural disturbance of the brain that cripples their ability to think, learn, communicate, and relate with others, as well as altering their perception of themselves and the world. Yet because these two complex illnesses have so many symptoms that could be indicative of other illnesses—among them, hyperactivity, irritability, rage, moodiness, wildly inappropriate behavior, and defiant outbursts—they are particularly difficult to diagnose.

The Search for Answers

In most cases, these illness aren't fully apparent until mid- to late adolescence. Looking back, parents of a child with schizophrenia might describe him as seeming "odd" or "a little out of it," making up words or withdrawing from usual social contacts. A child with bipolar disorder may swing from depression to manic euphoria and agitation, his mind racing from one idea to another. Euphoria is evident in a child feeling he is Superman, someone who can save the world. To the untrained observer, it may seem that a child appears relatively normal one day and out of touch with reality the next.

Compounding the confusion is that many adolescents can at times be moody, surly, sullen, and seemingly impossible to live with. Many distraught parents might indeed wonder if their child is seriously ill. For a correct diagnosis, the key is to understand the type, intensity, and duration of the symptoms and to carefully differentiate them from what is "normal."

These disorders are not as rare as many people think, each occurring in one in 100 individuals. Adolescent boys are more likely to exhibit schizophrenia than adolescent girls; bipolar

disorder is more equally divided between the sexes. Both have a strong genetic link and distinguishing between them may be difficult.

Delusions of the youngster with schizophrenia are often bizarre, tortured, and potentially quite dangerous. Voices from another planet that are exquisitely real to the child may urge him to stick his hand in a fire or jump out of a window. Detached and isolated, speaking in a flat, mechanical voice or at times highly animated, this child lives in a terrifying world of his own. In both illnesses, with proper medication and treatment, these psychotic symptoms may diminish.

For parents, the diagnosis of either disorder is difficult to accept. At first, many angrily deny a doctor's conclusions, for obvious reasons. Still, these illnesses are not the death sentences they once were considered to be. With many new medications available—and more on the horizon—experts see reason to be hopeful.

Needless to say, the sooner treatment is begun, the more effective it will be. Bipolar disorder can be well managed with a number of medications, including lithium or valproate or other mood stabilizers, as well as family therapy and education to fully understand the nature of the illness. Once properly diagnosed and treated, most patients can go on to lead productive lives.

For schizophrenia, the prognosis is better than ever before. Treatment includes a combination of powerful medications to curb symptoms, family therapy to increase understanding, and social, behavioral, and possibly vocational training to improve functioning. With some combination of these interventions, 80 percent of patients respond well. However, many may require supervised living arrangements, even as adults.

In the treatment of psychotic illnesses, perhaps the biggest hurdle to leap is a patient's tendency to discontinue the medication that he or she desperately needs to stay well. Time and again, patients who begin to feel better think, "I don't need these drugs anymore. I'm okay." But as soon as they stop treatment, they relapse. And stopping and starting medication may make the illness worse. Sufferers, especially those left untreated, are at serious risk for drug and alcohol abuse as well as for suicide.

The key, then, often lies with parents. Those who accept their children and encourage them to pursue the treatments available should in time be able to say, "My child has some measure of his life back."

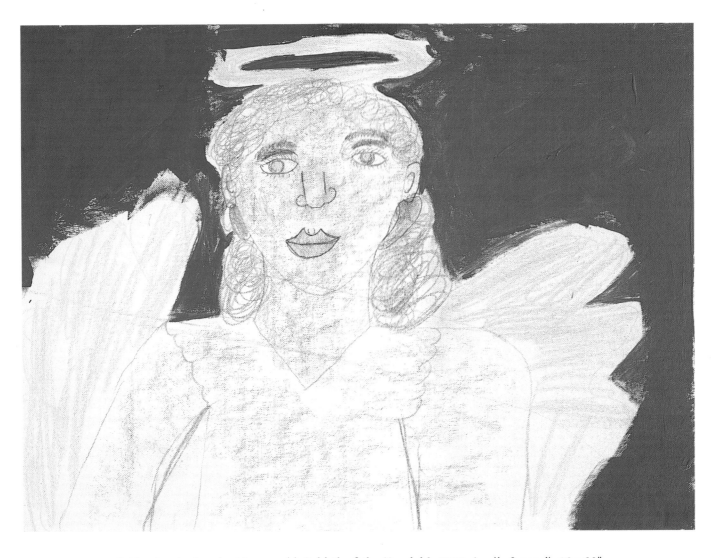

Schizophrenia. Female, 15 years old. **Rebirth of the Messiah!,** 1998. Acrylic & pencil, 16 x 20"

The messiah he takes me higher, halos in the wind it blows where
it stops nobody knows, it just goes and blows and blows.

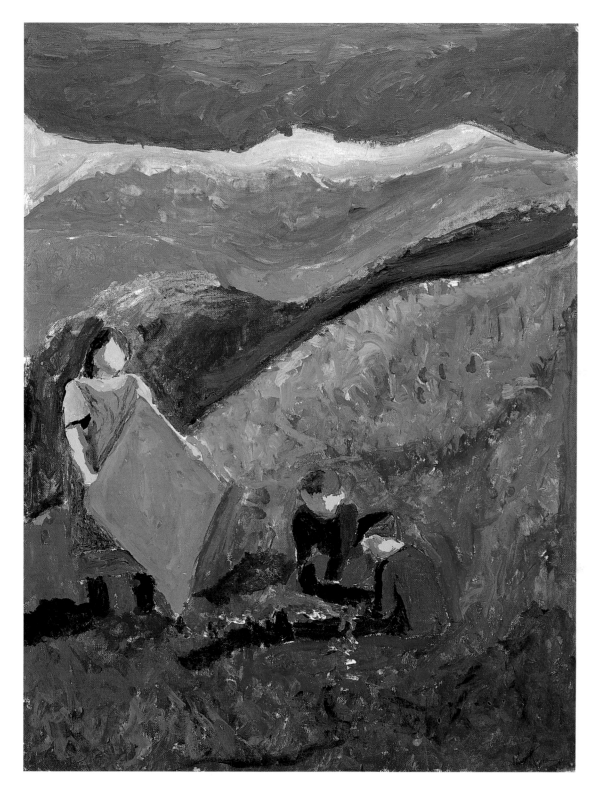

Bipolar disorder. Male, 15 years old. **Innocence of Youth,** 1998. Watercolor & acrylic, 24 x 18"

Three Children are stringing a kite on a hillside. The kite represents life. The children are young. The string represents events that lead up to that time of life when we are independent. I represent myself as the boy that is sitting watching the others. I am watching the others live their lives and learning from watching.

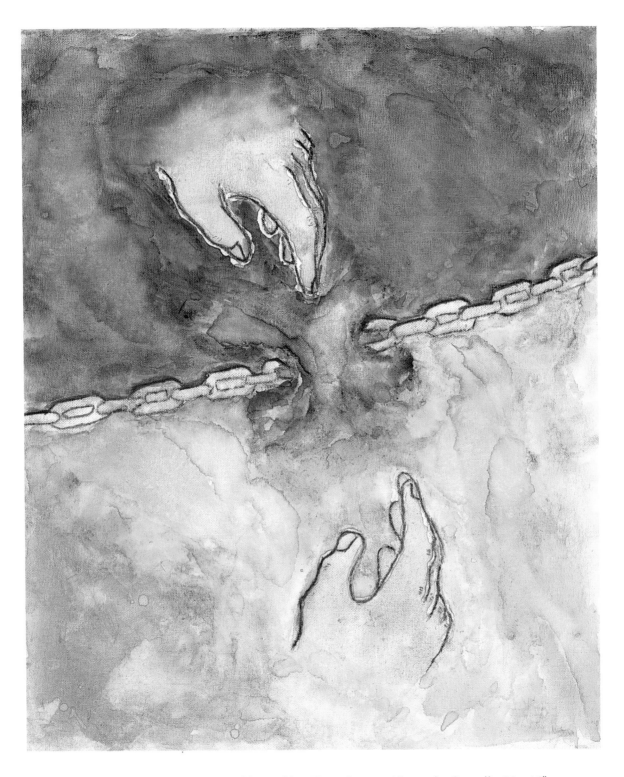

Bipolar disorder. Male, 15 years old. **Breaking Through,** 1998. Watercolor & acrylic, 20 x 16"

In this painting I am portraying myself on the dark side and other people on the light side. There is a chain in the middle because I used to put up an emotional wall and did not let others help me. I used drugs for help instead. Well, now the chain is broken and I let others help. I am not alone anymore.

Bipolar disorder. Female, 16 years old. **Empty Head and Peer Pressure,** 1997.
Chalk & pencil, 11 x 8½"

Bipolar disorder. Male, 14 years old. **Pacculypze,** 1998. Pencil, 18 x 24"

This art shows how kids worry about getting shot and if they'll live to see another day.

Bipolar disorder. Male, 8 years old. **At The Zoo,** 1998. Pencil & watercolor, 18 x 24"

This is me and my friends, at the zoo looking at the tiger.

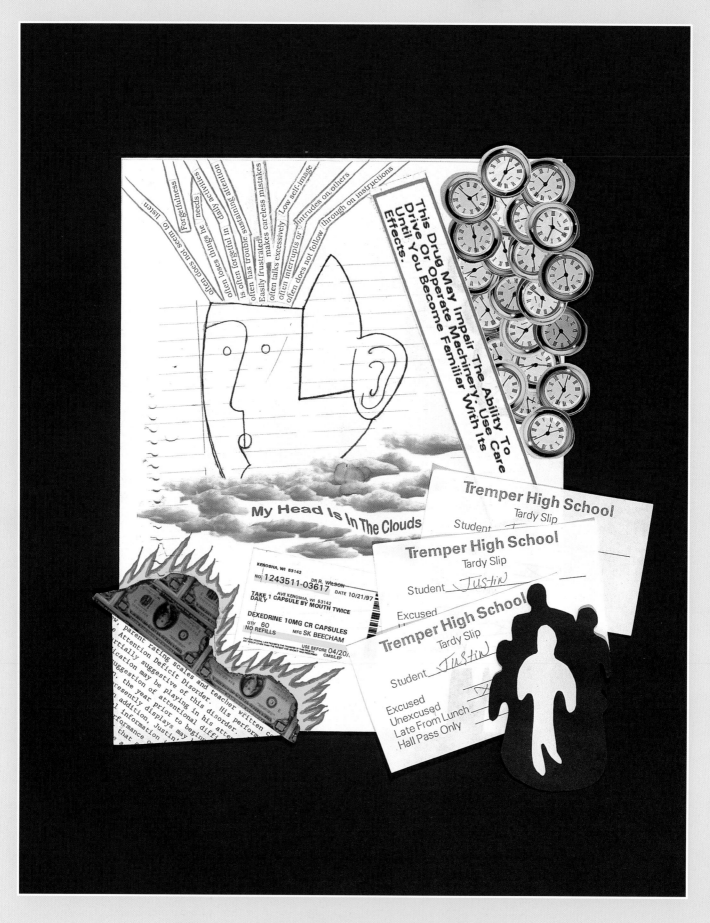

Male, 16 years old. **Me on ADD,** 1998. Mixed media collage, 11 x 8½"

Attention Deficit Hyperactivity Disorder
The Myths and Misconceptions
Surrounding Children in Perpetual Motion

FOR A LONG TIME, SEVEN-YEAR-OLD MARK'S PARENTS TRIED TO IGNORE THE FACT THAT SOMETHING was wrong. Their perpetual-motion son had trouble concentrating on just about anything—a book, a toy, a TV show, a conversation—for more than a few minutes. Mark ran instead of walked, squirmed instead of sat, shouted instead of spoke, and was never able to wait his turn. As a toddler, his parents had affectionately dubbed him the Terminator, since anything in his path—dishes, toys, the VCR—was in some way demolished either by his temper tantrums or by his overly exuberant play. Relentlessly demanding, Mark would throw a fit if his peanut butter sandwich was cut into fours instead of in half. Long ago, his parents stopped going out to dinner, since it was impossible to keep Mark in his seat. Such behavior won him few friends and, over the years, mothers would routinely request that Mark not be in their children's classes. Though he was bright, Mark's school record was erratic, alternating between flashes of competence and real confusion. As he got older, his behavior became so intolerable that the school principal informed his parents that, unless he stopped hitting his classmates or running out of the room, he wouldn't be allowed to return.

Allison, eleven, has never had many friends and her mother doesn't know how to help her fit in better. "She's always on the outside, looking in, unable to break into the conversation, or

Opposite: My collage explains how ADD affects me. The drawing of the head is split open and has phrases of my problems coming out of it. I included labels from my medicine bottle. I never have enough time to do what I have to do, or I am always running out of time. That is why I placed all of the clocks in it. The clouds stand for my daydreaming, which I do all the time in school. Almost every morning I wake up late for school, and arrive late too. I collected some of my tardy passes from school and included them. Another problem that I have is impulsivity. Whenever I see something that I like I have to have it no matter what. I work two jobs, and get paid every two weeks. The problem is that after a couple of days my moneys gone. That is what the dollars with flames stands for. (Money burning a hole in my pocket.) In the corner there is a clipping from my evaluation in Milwaukee. Last there are people in black and white. The reason I am white is because when I was ten I remember feeling like I was different, and I thought I was one of a few people with ADD. I also remember going to sleep over at my friends house, and telling my mom to let me take my medicine on my own. The reason was because I didn't know what people would think of me, but now it really doesn't bother me because I know a lot of other people who have it too!

even sustain one on her own. I have a feeling the other kids think she's a little strange," she concedes. Allison learned to read a year before her peers and would often spend hours perched on the window seat in her bedroom, poring over her books or staring dreamily out at the trees in the backyard. Until recently, she did well academically, but once middle school began, the work was harder, the assignments longer, and she had to move from classroom to classroom and teacher to teacher for each subject. Allison feels overwhelmed and anxious. "I used to think I was smart," she says sadly, "but now I think I'm dumb."

Growing up can be tough for kids like Mark and Allison—and tough for those who love them. After being shuffled from one specialist to another, both youngsters were finally diagnosed with *Attention Deficit Hyperactivity Disorder* (ADHD). Little known thirty years ago, now it seems nearly every active, rambunctious child has it. That's because this diagnosis has— wrongly—become a buzzword for any and all behavioral problems in children, the subject of myriad studies, and the stuff of volatile debates. Some critics claim it's the latest disease of the week; others, the newest cash cow for the pharmaceutical industry. What's more, because the condition is often successfully treated with stimulant or antidepressant medications, the most vocal opponents rail against doctors, parents, and teachers, saying children are being drugged into submission because impatient, frazzled adults are too busy or too tired or unwilling to control them any other way.

In truth, ADHD is a neurological syndrome that blocks a child from acting in a traditional way. A youngster with ADHD often acts up, talks out of turn, jumps from his seat, or wanders around the classroom. He starts many things and finishes few. Aggressive and loud, he may be shunned by classmates who, since he misses or misreads social cues, think he's weird or nerdy. He is often punished by teachers who can barely discipline, let alone teach, him. The result: academic and social rejection and a shattered self-esteem that can lead to depression, substance abuse, and a lifelong string of failures. It's no surprise that the high school dropout rate for youngsters with untreated ADHD is twelve times higher than it is for other children.

Although four key symptoms comprise the disorder—hyperactivity, impulsivity, distraction (a short attention span), and emotionality (a low frustration level), the term is misleading: this condition is not a *deficit* of attention but rather a *wandering* or *inconsistency* of attention. Youngsters with ADHD often focus as well as, or better than, most people—an intriguing project, such as building a skyscraper out of Legos, can occupy them for hours. But for them, the ability to focus is not voluntary. They can't help it if their minds drift, if they make careless errors, fidget in their seats, or yell out of turn. They don't decide: "Today, I will not pay attention in math," or "This time I'll ignore what Mom is saying."

More important, ADHD is not a learning disability any more than being nearsighted is. The distinction is critical: ADHD makes a child *unavailable* to learn. A learning problem makes him *unable* to learn. ADHD seriously affects learning, but once you treat it—and it *is* highly treatable—these youngsters learn very well.

A Tricky Diagnosis

Still, it's hard to describe the "typical" ADHD child, since the disorder manifests in so many ways. According to the latest diagnostic manual of the American Psychiatric Association, ADHD is an umbrella term with three subtypes: predominately inattentive type; predominately hyperactive/impulsive type; and combined type. An estimated 3 to 5 percent of youngsters—more boys than girls—have ADHD, though precise numbers are impossible to find since public schools lump the disorder with other behavioral conditions, private schools do not release such information, and many cases escape diagnosis. Then, too, there is no one test or scan that can prove that a child has this problem. Rather, diagnosis is often a process of elimination, painstakingly made after exhaustive observations, interviews, and histories taken from the child, his or her parents, teachers, and physicians.

Compounding the difficulty is the fact that all children display these behaviors from time to time. What parent hasn't lamented that her kids never listen to a thing she says? Who hasn't fallen into bed exhausted from chasing a toddler around all day? The class bully may have ADHD, but so, too, may the dreamy child who always says the wrong thing at the wrong time, or the quiet little girl in the last row who stares out the window watching a bird carve circles in the sky. A child with ADHD may be impulsive and restless in large groups, yet work well in small, structured settings and especially in one-on-one situations.

What's more, many other problems coexist with or mimic this syndrome. An anxious or depressed child may be hyperactive; a child who has conduct disorder may be impulsive; and a child with a vision or hearing loss may tune out in class. As in most psychological and behavioral disorders, the intensity and duration of the symptoms are key. In true ADHD, major symptoms must have been pervasive and persistent since the toddler years. It doesn't suddenly develop in a child.

Although we still don't know why one child has ADHD and another doesn't, studies point strongly to an inherited neurobiological link. Most kids with ADHD have a close family member—a parent, sibling, aunt, or uncle—who also has this problem. Experts used to think children outgrew the symptoms; now we know that's true in only 50 percent of cases. However, ADHD does not have to be a lifelong burden. There is much we can do for youngsters and their families.

Ready on All Fronts

How can you tell if something is really wrong? If your child's behavior is markedly different from those of other kids in his peer group, have him evaluated. Trust your instincts and don't be swayed by other parents, doubting spouses, or even specialists who are not trained in behavioral disorders. Once diagnosed, the key to helping a child with ADHD is a five-pronged approach.

First, educate *yourself, your child, grandparents, teachers, the soccer coach, or camp counselor — everyone who has contact with your child and who might in some way help or undermine a child's progress. ADHD affects every aspect of your child's life and relationships, so you will need to make a lot of decisions regarding treatment. Will medication help? Should he be in a special school or receive private tutoring? Does he need coaching in social skills, too? Parenting an ADHD child is emotionally draining and you will work much harder than other parents. And you may be baffled and infuriated by a child who seems utterly spoiled and selfish and who won't cooperate, concentrate, or listen, despite all your effort. You may even feel guilty that, more times than you care to admit, you can't stand the very child that you love. Family counseling should be part of your child's treatment. Check out support groups for advice and emotional sustenance.*

Establish a structure, *in school and at home. Get down to basics with good study habits — organize backpacks and desks, make lists, use a plan book or the computer as a study or organizing tool, break down large assignments into smaller doable ones, and so on.*

Children with ADHD need constant supervision, someone to coach and check on them to make sure they're doing what they're supposed to do when they're supposed to do it. Since they've met with so many failures, it's critical to help youngsters find and sustain some area of competence — a sport or hobby — that can make them feel good about themselves.

A healthy lifestyle — enough sleep, a well-balanced diet, exercise, and prayer or meditation provide the "pillars of brain maintenance."

And finally, when medication does work—80 percent of the time—the results are dramatic. After running a complete physical on your child, a psychiatrist trained in psychopharmacology may suggest a low dose of a stimulant medication, or an antidepressant, which will be carefully monitored every few months. These drugs have a paradoxical calming effect: they work to stimulate the brain's braking mechanisms, allowing a child to stop fidgeting and to focus better.

Acknowledging that a child has ADHD doesn't mean you must lower your standards or your expectations. It means you may have to change them. Millions of youngsters go on to achieve their goals—and those that do invariably cite the parents and teachers who stood behind them all the way.

Male, 16 years old. **Untitled,** 1998. Felt markers, 25 x 38"

Male, 13 years old. **Confused,** 1998. Felt markers, 18 x 24"

This is what my parents think. They don't know what to do with me.

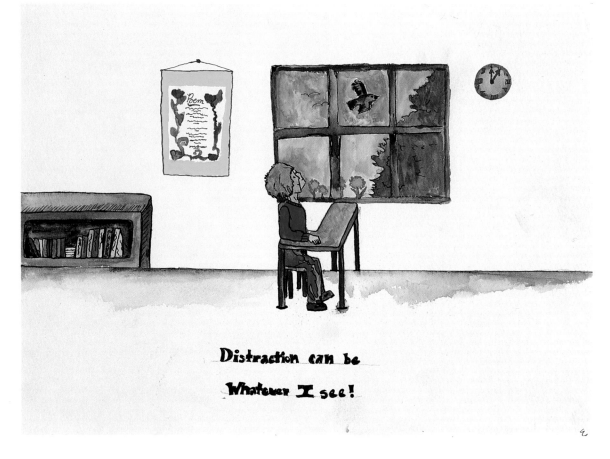

Female, 13 years old. **Untitled,** 1998. Felt markers, 8 x 11"

All of the things in this picture can be a distraction to a person with ADHD.
The double face shows how the person was concentrating but then becomes distracted.
I think having ADHD contributes to my love of Art it helps me see all the details.

Male, 6 years old. **Me,** 1998. Tempera & watercolor, 18 x 24"

This is a picture of me!

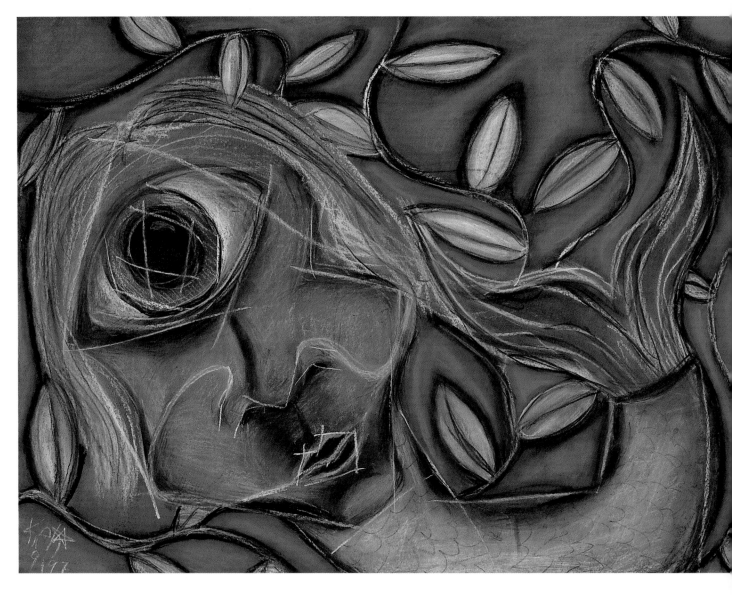

Female, 16 years old. **Cyclops,** 1997/8. Conte crayon & charcoal, 18 x 24"

It's seeing through the mind's eye. It's the freedom of imagination.

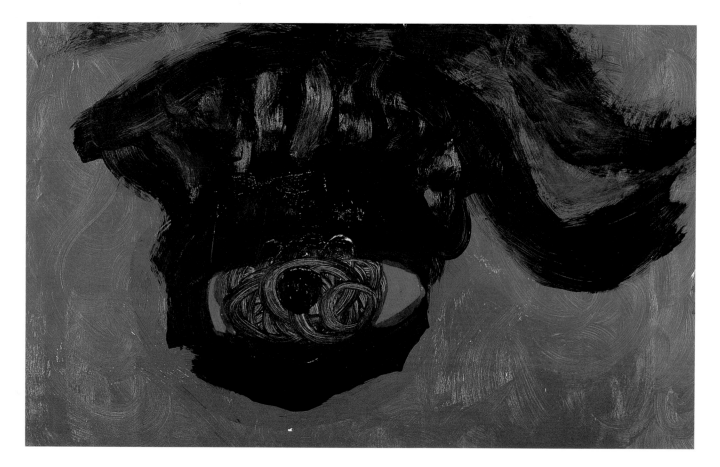

Female, 14 years old. **Angry Eye,** 1998. Acrylic, 12 x 18"

This picture means all that I have seen has driven me mad. Anger takes over me, but the ways of life take me on my journey. I see things over and over again, happening to me and other people. This binds me to the truth, even as I try not to remember. The blood that flows in me, carries my anger and hurt.

Female, 16 years old. **Bird with Worm**, 1995. Ceramic, 8 x 5 x 4"

Sometimes I feel like a bird. You have to get up early to get what you want.
Sometimes I get what I want, but not always. I just want a little apartment
and food in the refrigerator and clothes on my back.
My future husband next to me and to me, that's my happy life.

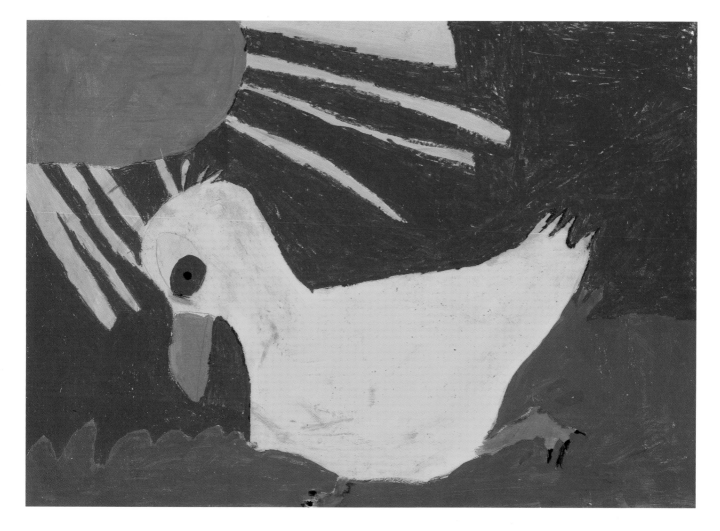

Male, 13 years old. **Duck,** 1998. Poster paint, 25 x 38"

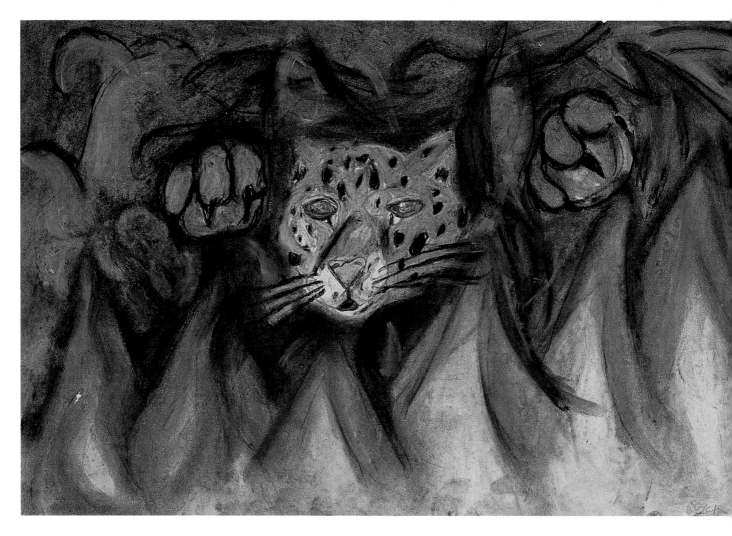

Female, 16 years old. **Tiger,** 1998. Pastel, 12 x 18"

This picture is really me. It expresses what I feel inside.
Sometime I feel like a tiger, swift and fierce. The fire means my anger.
The smoke is how confused things surround me. I feel like running away.

Male, 15 years old. **Skeleton,** 1998. Pastel, 9 x 12"

This picture talks about how I got stabbed in the back by one of my
best friends. The skeleton got stabbed in the head and shot in the mouth.
The skeleton is in hell for all the things he did. He must live in hell
for eternity with a knife in his head and a big hole in his mouth.

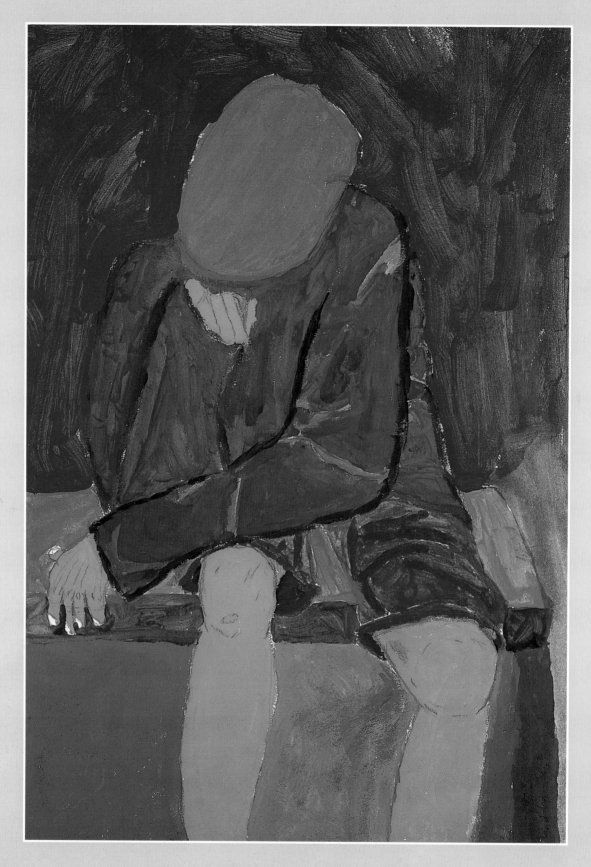

Male, 13 years old. **Untitled,** 1997. Acrylic, 14 x 12"

The colors are dark because its supposed to show he is undecided
and his face is especially dark because he can't decide what to do.

Learning Differences
When Smart Kids Can't Learn

Dyslexia is no longer something to be embarrassed about.
Holding your head high, knowing you can do anything—that's the key.
Whoopi Goldberg, Actor

A CHILD WITH A LEARNING PROBLEM FEELS SCORNED OR LEFT OUT MUCH OF THE TIME. IN A SOCIETY where academic achievement and the ability to produce a speedy answer to linguistic and mathematical problems are the first rungs on the ladder of a successful life, those who can't read, or for that matter can't add and subtract, may become all too familiar with failure at a tender age and in many arenas. Language development affects more than performance at school—it has a direct influence on social, emotional, and overall intellectual development. A child for whom learning is difficult may miss the gist of a story or misinterpret important social cues and may have trouble getting along with peers or have only a few friends. Years of struggling with academic tasks that come easily to others can leave him with a battered self-esteem and a crushing lack of confidence. He may be dubbed "lazy" or "dumb." It may take him much longer than others to learn to ride a bike and his poor hand/eye coordination may well prevent him from ever making the starting lineup on his Little League team. Perpetually lost and disorganized, unable to start, let alone finish, an assignment, he will inevitably trigger the impatience and ire of teachers. In fact, he may not find much respite at home. When evenings are punctuated by power struggles, when parents beg, bargain, cajole, or coax their child to study, it can be difficult for an already frustrated, anxious, and angry kid to feel that anyone really loves him for who he is and what he *can* do. Everyone is too busy focusing on what he can't do.

A New Definition of "Smart"

Since almost all children learn to speak with relative ease, we tend to take the development of language for granted and forget about the kids for whom the task is not so effortless. Yet an estimated 5 to 20 percent of youngsters in this country have a diagnosable learning problem caused by a glitch in the neurological functioning of the brain, and not, as many believe, due to

poor vision or hearing, emotional or social problems, or inadequate parenting. Regardless of its common usage, the term *Learning Differences* is still confusing and largely misunderstood—most likely because it applies to so many different types of seemingly unrelated problems.

It's essential to understand that there is no such thing as a "learning disabled child"; rather, there are various kinds of learning challenges. One child may have problems with visual perception (reversing letters, or difficulty in tracking words along a line, for instance). Another may have trouble processing information (that is, integrating, organizing, or understanding things he sees or hears), or sequencing (recalling letters, sounds, or words in a series) or accessing fine motor skills. These deficits may or may not be accompanied by attention, hyperactivity, or behavioral problems, making it all the more difficult to pinpoint the precise problem. But there is a common denominator: each shows a discrepancy between a child's overall intelligence and his ability to learn in one or more of the traditional ways. Such learning problems can't be "cured" and they aren't outgrown. These children *can* learn, but they have to follow a different path to gain knowledge.

In the best of all possible worlds, parents, educators, politicians, and policy makers would recognize that we all have different strengths and weaknesses and that it's imperative to encourage each child rather than limit our encouragement to only a handful. But the reality is that in our culture learning is narrowly defined. We place a premium on some types of intelligence and we measure those by testing and grading children in ways that ignore children who not only learn in different ways but also display individual talents.

We now realize that intelligence is more than vocabulary or mathematical skills. For instance, some people rank high in *spatial* intelligence, the ability to form a mental model of a three-dimensional world. Engineers, surgeons, sculptors, and painters have highly developed spatial intelligence. Others display *body/kinesthetic* intelligence, the ability to solve problems or fashion products using one's whole body, or parts of the body. Think of athletes, dancers, craftspeople. Some individuals are outstanding in *naturalist* intelligence. Like Charles Darwin or Rachel Carson, they are attuned to fine and consequential differences among plants and animals. Child prodigies such as Mozart and the violinist Yehudi Menuhin illustrate the biological link of *musical* intelligence. Still others manifest *interpersonal* intelligence, the capacity to understand people and what motivates them, how they work and how to help them learn to cooperate with others, evidenced by skilled salespeople, politicians, teachers, and religious leaders. And finally *intrapersonal,* or emotional, intelligence is the ability to look inward, to understand yourself, and relate to others.

How, then, can you help a child with learning problems feel good about himself? By

strengthening his natural intelligences and helping him hone the educational skills and strategies he needs to learn his own way, to learn strategies that compensate for problem areas. When parents are consistently involved, when they show unconditional love and support for a child, youngsters are motivated and armed to compensate for whatever learning differences they may have. Remember to get the facts so your expectations are reasonable. Although early identification and intervention of learning difficulties can be critical in preventing future academic and social problems, every child progresses at a different pace and developmental lags are perfectly normal. Many don't read or write letters and numbers until kindergarten, yet parents, worried that their preschooler isn't keeping up, may interpret a child's slower pace as evidence of a problem.

In general, by the end of first grade, a child who has problems recognizing and remembering letters; difficulty with word games, organization, and memory; and difficulty grasping cause-and-effect relationships or following directions warrants concern, not panic. Even then, the culprit may be the learning environment itself, or even an emotional issue. To be sure, first talk to your child's teacher, school psychologist, principal, or an educational specialist. Having an assessment—a battery of tests designed to determine a child's strengths and needs, can determine a specific educational package tailored to his learning style. Federal law requires that schools offer this free evaluation—which may also include medical, neurological, and psychological testing—if parents request it.

Be an advocate for your child. It's not easy being the parent of a child with a learning problem. You may spend countless hours finding the right professional evaluation, school, and support programs so that your child isn't lost in the shuffle. You may face intimidating teachers or bureaucrats who fail to give you the information you need and find yourself in an adversarial relationship with the people you need the most. What's more, as a child gets older, and the work load tougher, different types of problems may emerge that demand new strategies. As a parent, you have a right to be kept informed of your child's progress as well as what the school is doing to provide an appropriate educational environment for him. The state education department as well as the Special Education PTA in your school district can help you find your way through the maze of regulations and requirements.

Turn potential failures into success stories. Focus on your child's strengths: if he has poor hand/eye coordination, he may never be good on the tennis or basketball court, but may excel in swimming. By praising and encouraging activities at which your child does well, and by presenting him with challenges he has a reasonable chance of meeting, you deflect some of the pressures of academic failure and instead instill a sense of accomplishment.

Openly and honestly discuss a child's difficulties with the whole family. Ironically, the term "learning disability," first coined in the 1960s to eliminate the stigma placed on smart kids who had problems in school, has acquired a stigma of its own. Counter that by patiently explaining the problem so it loses some of its mystery and negative connotations. Acknowledge your child's frustrations and reassure him that you understand how hard school is for him. But underscore time and again that you're confident he can deal with it. By third grade, your child should understand his own problem and which areas he finds the most challenging. In due time, your child should understand and have the self-confidence to be his own advocate—and that's the best learning tool of all.

My American history teacher said to me, "Winkler, if you ever do get out of here, you are going to be great." When I was growing up, nobody knew what dyslexia was. I was called stupid, not living up to my potential, lazy. I was grounded so much I didn't see the moon for my junior year. How could I possibly be stupid? My parents were from Europe. My mother could speak several languages. She could spell in English. My father could do math in his head and I was in the bottom 3 percent in the country in math! Salespeople would give me my change back and I would stand there very confidently, praying to myself that they were honest because I had no idea what I was supposed to get back. What I have found out from then to now is that everybody has greatness in them. Everybody has a magnificent song and a learning challenge does not make you less than anybody else on the planet.

Henry Winkler, Actor

My stuttering was only moderate; others suffer more. Still, I lived many days in fear of speaking. At the age of 30, I found a clinic that helped me. My parents had sent me to speech therapy, but that was no help. Had they known a little more, I would have been helped sooner. What a difference that would have made in my life.

John Stossel, Reporter, *20/20*

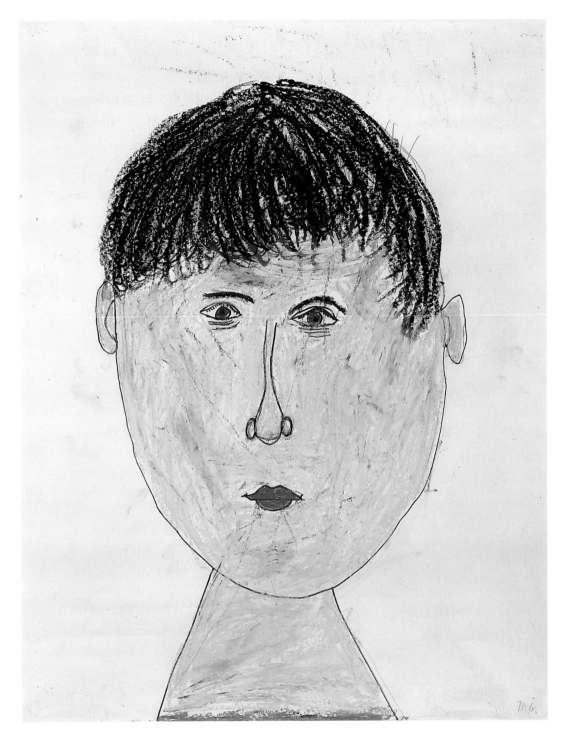

Male, 11 years old. **Untitled,** 1995. Pastel, 20 x 14"

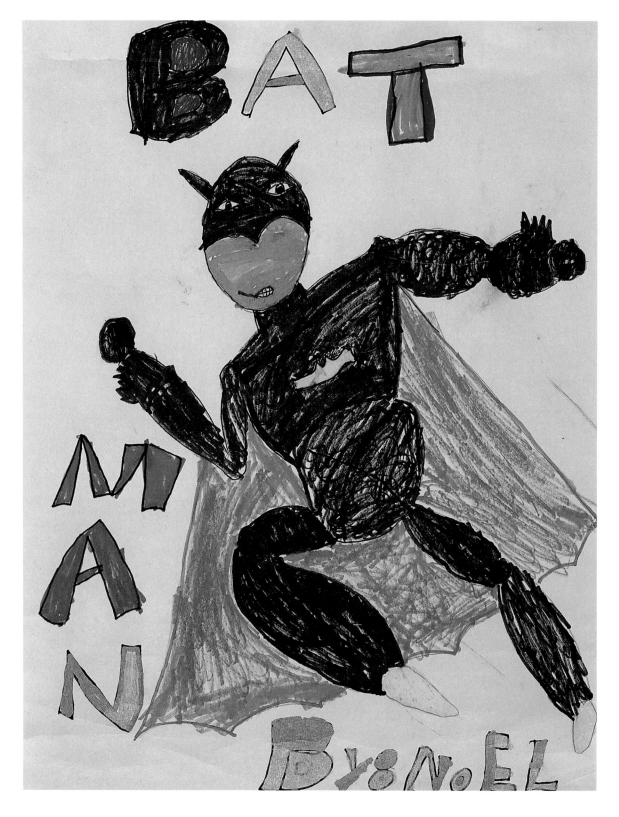

Male, 10 years old. **Batman,** 1998. Felt markers, 24 x 18"

I'm a great artist, right??

Female, 9 years old. **Untitled,** 1997. Crayon, 12 x 10"

Male, 5 years old. **Overstimulated,** 1998. Felt markers, 12 x 9"

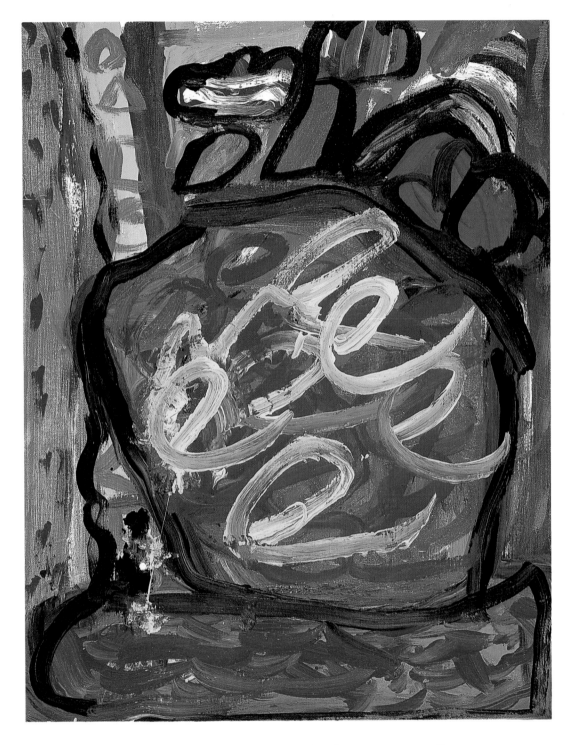

Female, 9 years old. **Untitled,** 1997. Oil on canvas, 12 x 10"

Female, 17 years old. **I Am 17,** 1997/8. Mixed media, 20" circle

I've had problems in my life because at 15 months old I had a brain tumor removed. The cancer has not returned but I get tested every 6 months just to be sure. During my 17 years, I have needed rehabilitation for learning disabilities, hormone deficiencies, seizures, learning independent living skills, and making and keeping friends. I love art, sewing, and cooking. Since 4½ years old, I have been doing art therapy to feel better and have fun.

Male, 11 years old. **Untitled,** 1991. Acrylic, 30 x 40"

Male, 9 years old. **Untitled,** 1993. Mixed media, height 20"

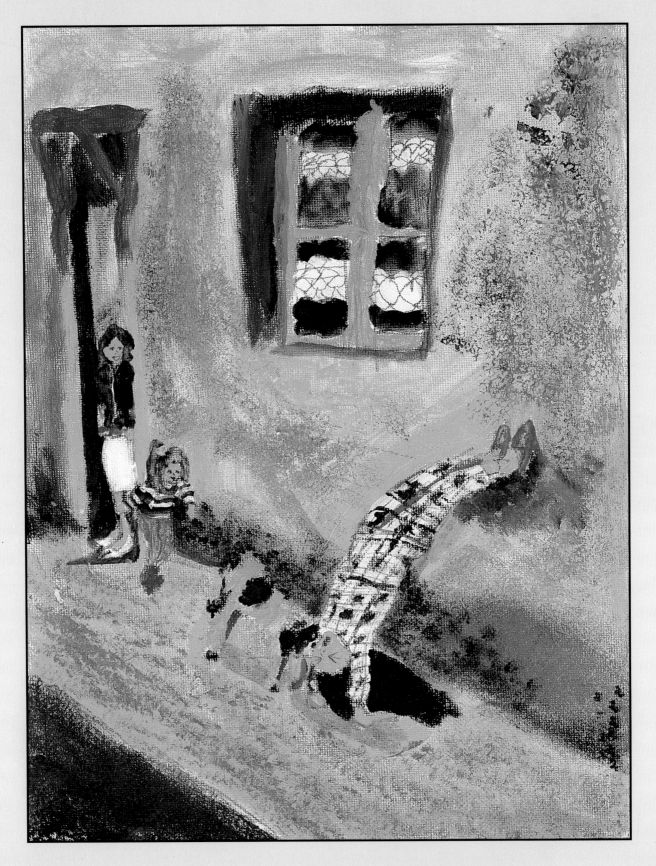

PDD. Female, 13 years old. **Three Girls and a Dog,** 1998. Acrylic, 12 x 9"

The girl is walking the dog and the dog is licking the girl.
The girl is screaming for the dog to stop and the lady is watching her and smiling.

Pervasive Developmental Disorders and Autism
Children in Their Own World

AT THREE, JACK HAD MEMORIZED EVERY NURSERY RHYME IN *THE COMPLETE MOTHER GOOSE,* TAUGHT himself to read, and knew more about operating the family computer than his parents did. Yet Jack's parents sensed something wasn't right with their second son. They couldn't understand why he writhed in agony when they went to kiss or cuddle him, threw himself on the ground in wall-shaking tantrums if he didn't get his way, or wailed at the sound of a neighbor's distant lawn mower—a sound his parents and brother could barely hear. Jack never showed any interest in playing with other children. "This is going to sound crazy," Jack's father recalls, "but it's as if he looks right through another kid. I don't think he's even aware that they're there."

Adding to the confusion was the fact that while Jack's motor milestones were somewhat slowed, he talked early. Still, his language was odd—with neither modulation nor change of tone in his voice. Particularly upsetting was the way he cycled into major public tantrums for no apparent reason, becoming completely inconsolable. "Everyone thought he was just spoiled, and that we were lousy parents," said Jack's mother. "Even my in-laws complained that we weren't tough enough."

Jack's parents—savvy and well read—knew that youngsters develop at different rates, and tried to reassure themselves that Jack, like his big brother, would be fine, too. But over the next three years, they ricocheted from one therapist to another in a vain attempt to figure out how to help their increasingly disruptive, despondent, angry son. One professional said they weren't strict enough and suggested couples therapy to end the bickering and tension that increasingly permeated their marriage. Another thought Jack had food allergies, while still another ran a battery of tests to determine if he had a learning problem. Finally, a child psychiatrist noticed that Jack had an odd habit of talking in the second, rather than the first, person: Instead of saying, "I'm hungry," he'd report, "You hungry." After five more months of extensive diagnostic tests to rule out many other problems that show similar symptoms—ADHD, hearing loss, depression, language disorders, mental retardation, or other developmental problems—Jack's parents learned that their son is suffering from Asperger's Syndrome, one of four *Pervasive Developmental Disorders* (PDD), a broad category of developmental problems that seriously affect a child's ability to receive and process information and then respond to it appropriately. In a sense, Jack is fortunate. Asperger's Syndrome is one form of PDD less commonly associated with mental retardation; at the other end of the spectrum is autism.

Between one hundred thousand and two hundred thousand youngsters are diagnosed with

pervasive development disorder each year, three to four times as many boys than girls. Although the incidence and severity of symptoms vary widely, children with autism or one of the PDDs seem to live in a world of their own. They have enormous difficulties forming emotional attachments, even to parents or family members, and are often unable and unwilling to have any physical or even eye contact with others.

As early as infancy, a child may seem indifferent or averse to a parent's physical affection, shrieking and wrenching away when anyone tries to get close, or, like Jack, may not even notice another's presence. These youngsters also have serious language problems and, because of their long delays in learning to speak, are sometimes mistakenly believed to be deaf. However, while their hearing is normal, their brain's ability to process sounds is not. When they do speak, they may utter strange noises or words, or parrot back other people's words—what doctors call "echolalia." Often, their speech is stilted and monotonal and, again like Jack, they tend to confuse their pronouns.

What's more, a child with PDD may respond to his environment in baffling or inappropriate ways. He may explode in a violent tantrum when asked to speak more softly, yet appear oblivious to a bright light shining directly in his eyes or to pain when he hurts himself. Also common to this disorder are compulsive, ritualistic behavior and movements. Rocking, twirling, or spinning objects entrance children with PDD and they may mimic the circular movements with their own bodies or methodically line up paper clips or rubber bands on a desk.

About 80 percent of children with autism are also mentally retarded, though some, like Dustin Hoffman's character in the movie *Rain Man,* have a genius-like ability in one, but usually only one, area. For reasons we still don't understand, these autistic *savants* possess a unique skill, usually involving rote memory or visual skills. They may be mathematical geniuses, able to instantly compute the square root of any number or precisely recall every winning state lottery number for the past several years.

Although pervasive development disorders are congenital, some cases, like Jack's, are not detected until the toddler or preschool years, when parents begin to suspect something is wrong. PDD can be tough to recognize because its symptoms mimic so many other problems, and also because youngsters with a less severe form of the disorder may meet, or even exceed, some classic milestones in a few areas.

What is the future like for children with PDD? That depends on the severity of the symptoms in the first place, and how early and intensive the intervention is. PDD cannot be cured, but a multidisciplinary approach, involving medication to reduce symptoms, behavior modification, language therapy, and the teaching of social skills, can help youngsters to lead relatively normal lives. Some may be able to move into a mainstream school setting, but most will need special education classes, or one-on-one therapy, either at a home or in a specialized school, supplemented by family members who can learn the necessary behavioral management and stimulation techniques.

In many cases, constant supervision, surveillance, and attention is needed for youngsters. The challenge for parents is daunting. Frustrated and emotionally drained, many suffer from guilt that they could have done, or should be doing, something differently. It's not easy to reconcile past dreams with the reality of a child's problem. Fortunately, many parents of children with PDD find that support groups and experienced professionals help them accept their children for who they are.

The therapist said, "So how do you feel about raising an 'imperfect' child when being perfect is so important to you?" I'll never forget it because in that moment I let go of something, some antiquated barometer of good and bad that had been ruining my life.

My perspective is constantly changing in raising my boy, Mac, now eleven. This mother-love is the strongest connection I have ever felt and finding myself the guardian of this innocence has me questioning everything, all the time.

My son falls under the spectrum of Pervasive Developmental Disorder (PDD), and also has Attention Deficit Disorder (ADD), with some autistic tendencies. You get a little weary of all the terms and diagnoses you seek out in an effort to understand your child; you get angry and say this is not my child, he is soul and spirit, he is unique Mac is deeply compassionate, sweet, and kind and enormously frustrated with his neurological short-circuitings.

Shortly after birth we realized Mac's behavior was different. He made little eye contact, preferring instead to arch his back and stare above our heads. We joked and said he was reading our aura—maybe he was. All his skills were slow to develop and some a little peculiar; when he crawled, he never engaged his legs but used his strong upper body to pull himself around.

Mac's father and I felt we needed professional help and as he grew we were given a series of diagnoses. It was important to us to know where he was strong and where he was challenged. I am genuinely surprised by the denial some parents display concerning their kids. I'm grateful I realized early on that I am not my son, that quite simply, his challenges are not a reflection of me.

It has helped me greatly to realize and accept that Mac and I have chosen to grow together. My biggest obstacle in parenting him has been enormous self-doubt. When I approach my mothering with love, not fear, I have the best instincts in the world.

When I am fearful, I pray. At first I prayed for him; not that he would be "cured," make a good living, or have a happy ending. I prayed he would discover his special gifts, his talents, and that they would engage him happily in his life. Then I started praying for myself. I continually pray for insight, clarity, and patience, for the ability to be present with my boy so I can see the doors and windows he opens in his own way.

What helps me the most is Mac. He is innocent, whole . . . beautiful. I need him in my life as he is, to love him as he is. To love him is to love myself.

Christine Andreas, Broadway Actress, *The Scarlet Pimpernel*

Autism. Male, 14 years old. **Girl In Green,** 1998. Watercolor, 12 x 9"

I like girls in green dresses and blond hair.

PDD. Male, 7 years old. **Extra-Terrestrial Space Robot Alien,** 1998. Crayon, 18 x 12"

PDD. Male, 10 years old. **Untitled,** 1998. Felt markers, 12 x 20"

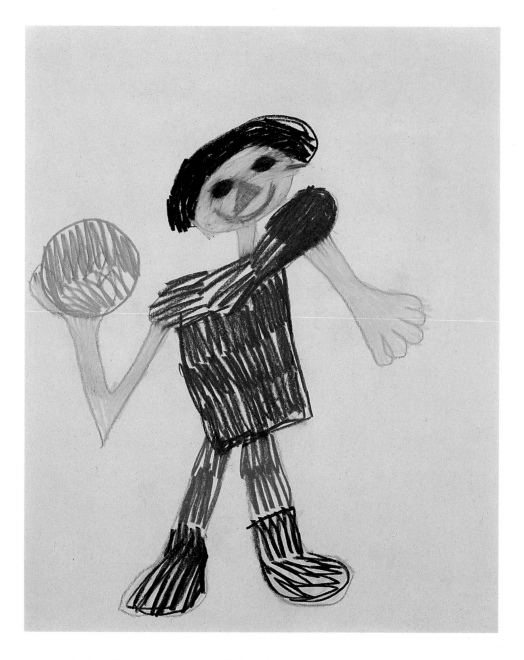

Autism. Male, 16 years old. **Ball Throwing,** 1998. Colored pencil, 11 x 8½"

Feel hurt inside because I healthy person.
I like people who are right to me—gentle with me.

Autism. Male, 10 years old. **Angry,** 1996. Chalk, 34½ x 24"

Me at school being upset because me hate doing their homework.
They ask me to do many things that are stupid. Me already know
that stuff, like spelling harder words, like multiplication.

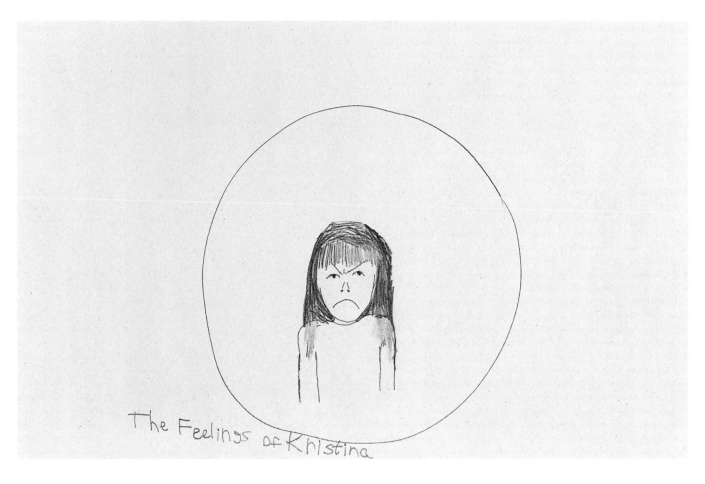

PDD. Female, 12 years old. **The Feelings of Kristina,** 1998. Pencil, 12 x 18"

This is me feeling angry.
Because kids bother me, make fun of me, singing the ABC song and tease me.

PDD. Male, 16 years old. **Divine Elegance,** 1998. Oils, 9 x 12"

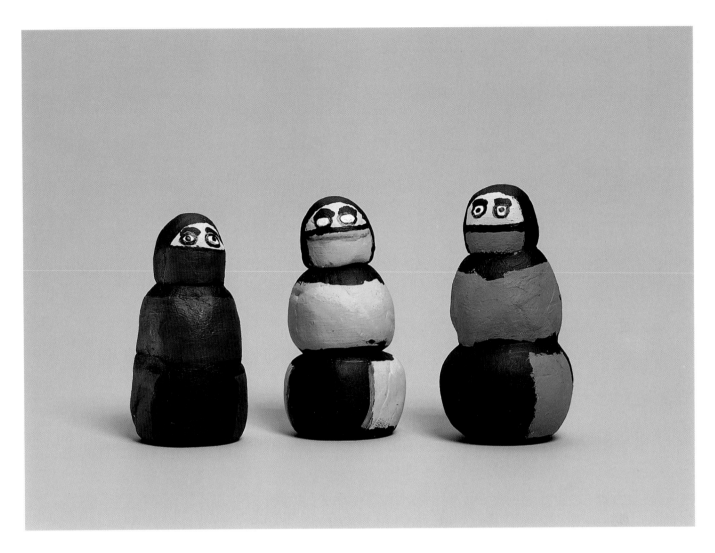

PDD. Male, 18 years old. **Untitled,** 1998. Clay, 3 pieces, each 4 x 2"

Painting helps calm my nerves down. Making art helps me relax. It helps me get rid of my tension and helps me feel happy. I want to help other people learn to make art. The ninjas I made are special to me because they are warriors who can use their powers for good. Also, they remind me that my Dad used to teach me martial arts.

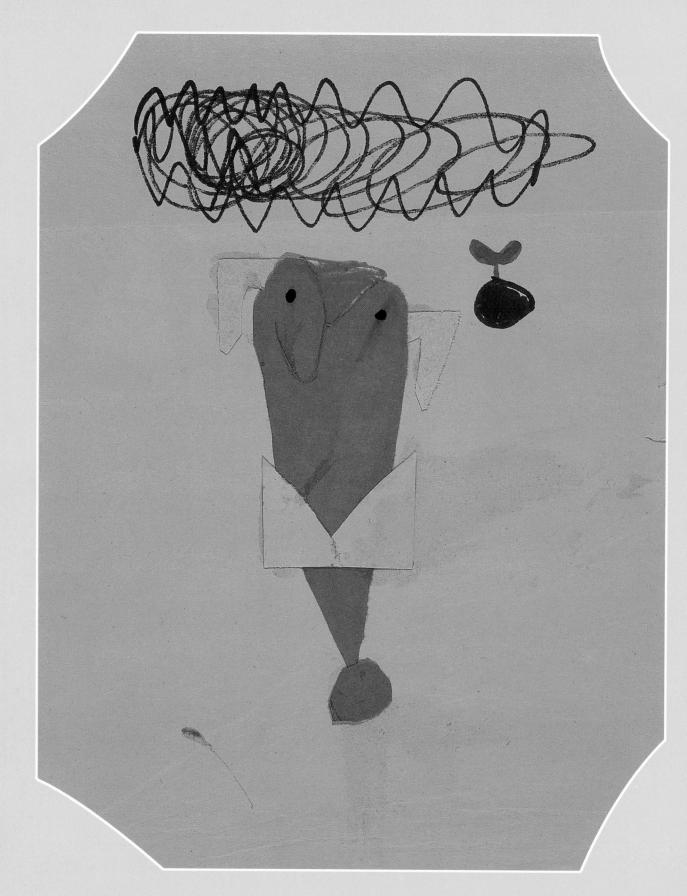

Sexual abuse by half-sibling. Female, 6 years old. **Untitled,** 1997. Construction paper & felt markers, 12 x 10"

Girl with pink hair oops no arms!

Post-Traumatic Stress Disorder

The Legacy of Survival

A TORNADO IN GEORGIA RIPS FAMILIES FROM THEIR HOMES, HOMES FROM THE EARTH. A FIVE-year-old child, crouching in the basement with his parents, sees his baby brother swept from his mother's arms and now won't let his mother out of his sight.

A ten-year-old boy is brutally assaulted by a family member while his parents are at work. He miraculously escapes with a broken collarbone and abrasions on his face and hands. Although his body heals, the emotional wounds are evident by his recurring nightmares.

A car bomb explodes in front of a federal office building in Oklahoma City in April 1995, and among the dead are nineteen children who had just been dropped off at the day care center there. Across the country, children who see repeated tapes of the bombing on the TV news or over-hear newscasters' sound bites are afraid to leave their parents' side.

They are trauma's littlest victims, suffering from an illness most people associate only with soldiers in combat. Post-Traumatic Stress Disorder (PTSD) is characterized by an array of acute, disabling psychological, behavioral, and physiological symptoms triggered by a severely fright-ening experience and persisting long after the event has taken place. But it wasn't until the late 1970s, when nearly one million Vietnam War veterans began to report vivid flashbacks, panic attacks, and other symptoms months or years after they had returned home, that the term entered the vernacular. Now we know that while reactions to extreme stress vary with age and tempera-ment, a surprisingly high number of children suffer from PTSD.

The number of children affected is staggering. Every year, at least three million children—nearly the entire number of young men and women serving during the ten-year period of the war in Southeast Asia—are victims of PTSD. Perhaps they witnessed an isolated terrifying spectacle, such as a devastating hurricane, tornado, or other natural disaster. Or perhaps their ordeal was chronic, persistent domestic or community violence or repeated physical abuse. Whatever the initial trauma, these children live in a constant state of fearfulness, reliving the experience over and over again in their play, their sleep, their drawings, their speech, or their relationships with others, as they try to make sense of the incomprehensible. Worse still, because some people

don't believe that children can be affected even by a single traumatic experience, their symptoms are frequently overlooked or dismissed and many never receive treatment.

What is Trauma?

Frightening things happen to kids all the time, whether it's falling out of a tree, needing stitches for some wound, experiencing the death of a beloved grandparent. In most such cases, children are scared, sad, angry, or confused for a period of time. Soon, however, they harness their inner strength and move on with a sense of confidence that they can cope when times get tough. It may even be that when something reminds them of the past, they may become depressed again for a while. But the grief or panic doesn't interfere with their everyday life.

Feeling traumatized is a different kind of being scared. When anyone, young or old, experiences a real or perceived threat to his life, certain physiological changes are automatically triggered: the heart rate quickens, stress hormones pour into the bloodstream, blood pressure and respiration soar, pupils dilate, muscles tense, and the brain freezes out non-critical information. In the immediate aftermath of trauma, almost everyone will have acute symptoms such as nightmares or fearfulness. But sometimes the part of the brain that triggered the initial alarm goes into overdrive and never calms down. Recurring intrusive recollections of the event cause an individual to remain in a perpetual state of fear and anxiety, on the lookout for signs of danger. Or, like possum, children may withdraw: emotionally numb, their impassive, blank faces register nothing, but their hearts are racing and their brains are shrieking "Danger!" If the trauma is prolonged, the chances are great that the emotional, physiological, and cognitive scars will be permanent. Here, their minds literally stop functioning in a normal way. Their internal landmarks, the signposts and signals we use to help guide us through life, become skewed.

Some signs of trauma are easy to spot. Infants cry and cling more than usual. Preschoolers regress to soiling their pants, sucking their thumbs, or stuttering. School-age children are unable to concentrate on work or complain of headaches, stomachaches, nausea, or nightmares. They may even convince themselves that the terrible ordeal they witnessed will happen again—and worse, that they were responsible for its occurrence in the first place.

However, because many trauma symptoms are less obvious, they are easy to miss or misinterpret—the withdrawn child with the blank facial expression won't be noticed as much as the child who wakes up screaming in the middle of the night, though he or she may be no less wounded.

Triumphing over Tragedy

Why are some children able to withstand, even triumph over, shocking events while others are crushed by them? Those who work with traumatized kids have learned that to some extent the ability to withstand high stress is a question of temperament. Some more easygoing babies are

simply more resilient. So, too, are youngsters raised in generally loving, nurturing homes—or those who have found, if not a parent, then a teacher, a coach, or another relative who cares about and believes in them. The age of a child, as well as the duration and source of the trauma affects a child's ability to cope, too. A ten-year-old who fully understands that his neighbors are at war with each other could be more traumatized than an infant in similar circumstances—but it's wrong to assume that the infant will be unaffected because she lacks understanding or the words to express what she sees. Babies bear the scars of trauma, too, and unless they receive therapeutic intervention, the consequences become visible later on. A youngster will also be more severely affected if the terror is intentionally inflicted—a murder, say—rather than the result of a natural disaster. Then, too, a child who witnesses abuse or killing on a daily basis may be so drained from the constant brutality that he can no longer summon the necessary coping mechanisms.

Of course, most children will never be exposed to such horrors. But in a world where buildings are blown up, tornadoes swallow whole towns, and planes crash minutes after takeoff, children see and hear so much that can frighten them and it becomes a challenge to protect them. In fact, recent national surveys of young people in inner city, suburban, and rural areas report that children are worried about far more serious issues—violent crime, homelessness, drugs, and divorce—than most grown-ups imagine.

Honestly Express Your Own Fears

So how can you best help a traumatized child? If a child senses that you are secretly worried, she will keep her worries to herself. The idea of random violence terrifies children, shattering the sense of order, routine, and predictability that makes them feel safe. Pretending you aren't afraid won't work. However, by admitting your fears, and showing that you can handle them, you show how to cope and you send the message that they can overcome their fears.

Don't Dismiss Their Worries

Let children know you're available to talk, and when they do open up, encourage them to discuss their fears. Emotions and feelings deserve to be acknowledged and addressed in a loving, comforting way. If you deny or minimize what a child feels, you handicap her ability to put life's ups and downs into perspective and she'll grow up distrusting her own judgment. Of course, many times we don't have a good explanation for why something happened. In that case, simply listening and giving a child a chance to say what she's thinking can be what's called for.

Make It a Time of Learning

Keep in mind that, until they are six or seven, most children do not have the ability to logically think through something that has happened or to put into perspective an event they see on

television. A four-year-old watching repeated telecasts of the bombing of the office building in Oklahoma City may not think he's seeing a tape of the same explosion. Instead, he'll think someone is bombing several buildings across the country.

That's why it's critical to limit exposure to the news or to frightening, violent television shows or movies. However, if your children do see or hear about something that scares them, use it as an opportunity to teach concepts such as probability. Put your explanations in terms they can understand: to a four-year-old who is afraid a tornado will strike his house, you can say: "Will a zebra walk into the living room? Probably not, right?" To your seven-year-old who worries that the airplane you're taking to Grandma's will crash, you can say: "You fell off your bike last week, and that was a bad thing. But it doesn't mean you shouldn't ride your bike. Well, it's the same thing with an airplane. Sure, sometimes planes crash. But most take off and land safely—you never hear about those." Or, use your own life as a reference to point out positive events and changes. Also, remind your children that we've learned a lot about how to protect ourselves from environmental threats, and how to make the world and our neighborhoods safer. Bring their concerns home by discussing safety in the house, at school, in your community. If there is any good news to come from terrible events it's that youngsters have the opportunity to learn from their parents about how to handle the powerful and, at times, crippling emotion of fear.

Sexual abuse from infancy to age 4. Female, 6 years old. **The Frighteness in Life,** 1994. Acrylic, 18 x 24"

This picture is when I was five years old. I see a tornado and a haystack and I feel in this picture frightened because tornadoes are dangerous and a little bit cool. I guess that means it can sometimes feel exciting to be scared. I feel that the tornado is dangerous because tornadoes can break down houses and I feel that it's cool because I've never seen a tornado before.

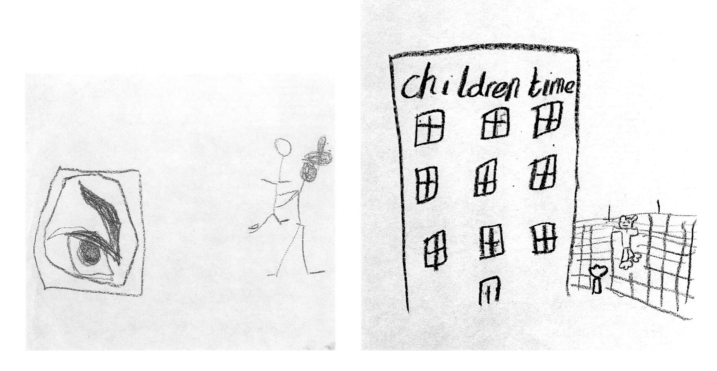

Oklahoma bombing. Male, 4 years old. **Untitled,** 1995. Crayon, 8 x 56"

Therapist: The child suggested where to put the red safebox with his mother, twin brother, and therapist.

Oklahoma bombing. Male, 5 years old. **Untitled,** 1995. Crayon, 8 x 11"

Therapist: This image of the young boy being saved was made six and a half months after the bombing.

Oklahoma bombing. Male, 6 years old. **Untitled,** 1996. Crayon, 11 x 8"

Therapist: Here is the child's description of what a bombing memorial should look like—the building would have "very strong windows with glass that does not break."

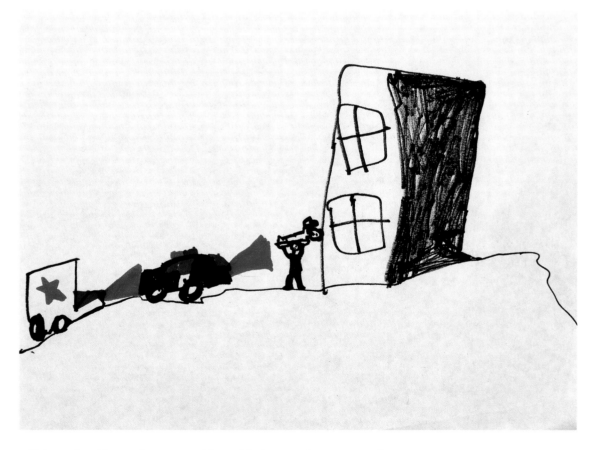

Oklahoma bombing. Male, 5 years old. **Untitled,** 1996. Crayon, 8 x 11"

People getting saved.

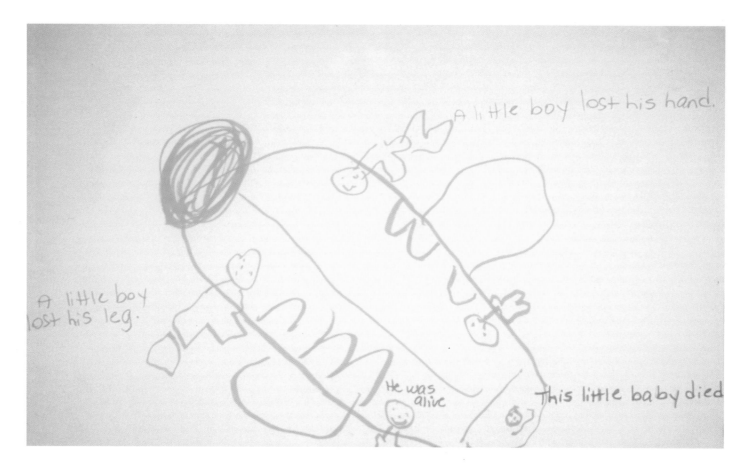

Avianca plane crash. Female, 6 years old. **Untitled,** 1990. Felt markers, 8 x 11"

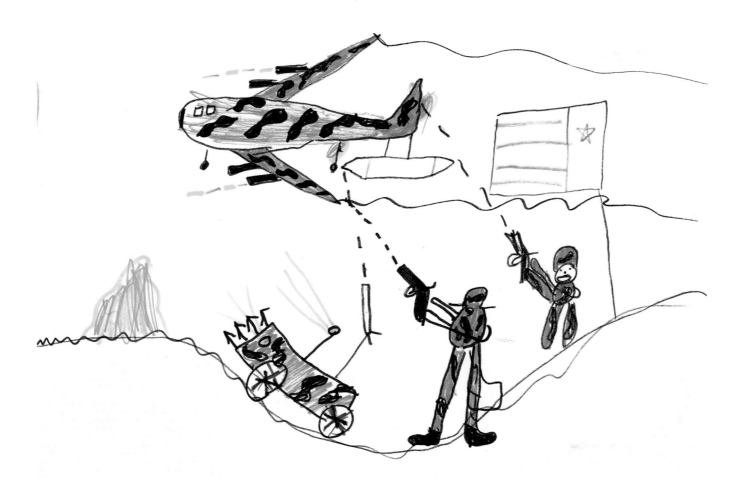

Immigrant from the Eastern Bloc. Male, 9 years old. **War,** 1997. Felt markers, 10 x 12"

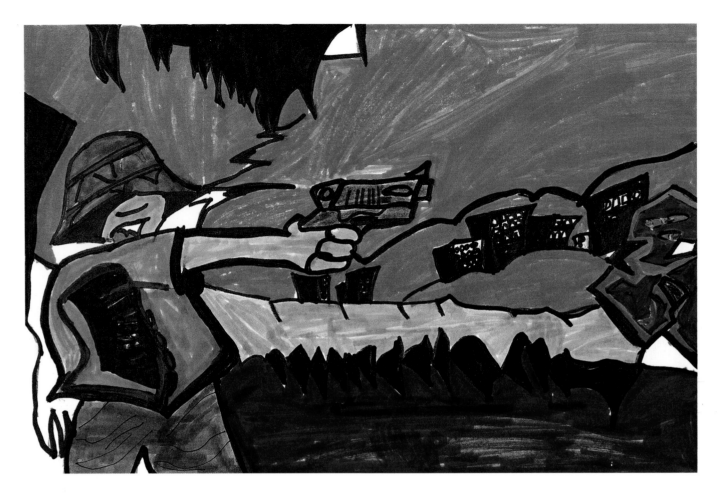

Witness to violence. Male, 14 years old. **Madness,** 1997. Felt markers, 12 x 18"

The reason I picked the name for the picture is
because it shows anger inside the character in the picture.

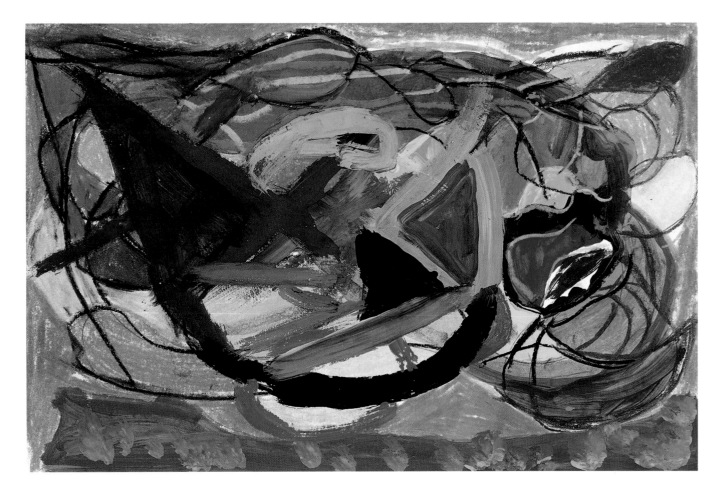

Witness to violence. Male, 14 years old. **Confusion,** 1997. Acrylic & pastel, 12 x 18"

I picked this name for the picture because it shows
different media and also different shapes and figures.

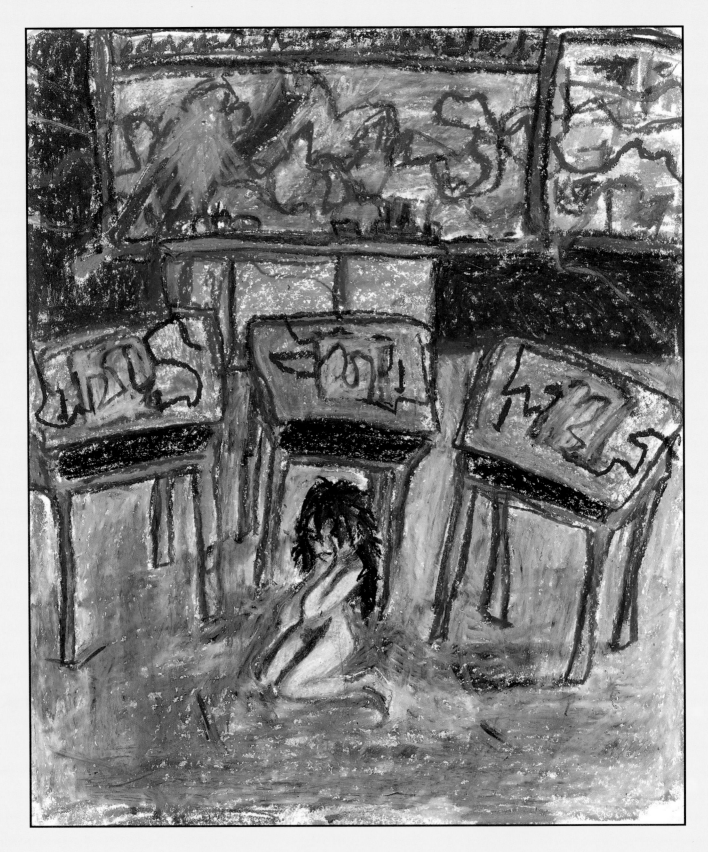

Female, 18 years old. **Chaos Education**, 1998. Oil pastel, 14 x 11"

I was sexually abused at a young age and I didn't say anything until early puberty. This severely
affected my psyche for about 7 years. This is about how I view those years from in school where it
affected me most. What I remember is a dream memory chaos where I was isolated and ignored.

Abuse
The Physical, Emotional, and Sexual Abuse of Children

When I was a child, there was no help whatsoever. No matter what the problems were, unless they were physical, there was no understanding. You just had to live through it and grow up the best you could. Finally, as a society, we have begun to be mature enough to look at the issue of child abuse without the clouds of preconceptions. We have taken giant steps forward.

Everybody has to have a safe place. When there is no safe place, you begin to see evidence of depression, suicide attempts, and what is called mental illness. Basically, it is an attempt to cope with the uncopable.

Christina Crawford, Author and Child Advocate

INSTANCES OF ABUSE, OFTEN A FAMILY'S DEEPEST SECRET, ARE USUALLY LOCKED BEHIND CLOSED doors and rarely reported. Yet this much we know: every ten seconds, a case of child neglect or abuse is reported in this country—in total, almost three million reports and one million confirmed victims each year. Abuse may occur with parents, nannies, preschool or nursery school teachers, aides, baby sitters, or relatives—anyone, in effect, who has repeated contact with kids. An estimated thirteen hundred children die each year from injuries inflicted by those who are supposed to love and care for them. In 42 percent of those deaths, the families or caregivers had previously been reported to child protection agencies. Yet each time, either nothing was done, or the children were returned to the homes where they continued to be abused. One in three girls and one in ten boys are physically and/or sexually abused before they turn eighteen, almost 90 percent of them under the age of five. Though the words "child abuse" conjure up images of bruised and bloodied youngsters, millions more—perhaps as high as two to six million—are subject to mistreatment, verbal abuse, and neglect before they reach adulthood. Their emotional injury may be less visible but no less painful.

Yet such high numbers often have a strangely numbing effect, like body counts in a war thousands of miles away. Each week, it seems, newspaper headlines and TV news anchors report the grim news that yet another child was battered, sexually abused, or killed by a parent, relative, or caregiver. We recoil in horror, then quickly turn the page or change channels. In the face of such widespread horror, we are overwhelmed. We don't want to believe what we hear or read, or we simply don't know how to help. If we suspect abuse in the families of our friends, neighbors, or relatives, some of us may question whether we should get involved, or whether our interference will backfire and cause needless anguish. Instead of acting on our suspicions, we worry that we may be identified, or suffer reprisals by the abuser, if we do. Even more disturb-

ing, recent nationwide polls report that a surprisingly high number of people believe that parents have the right to discipline their children any way they see fit—and that a good hard spanking is sometimes necessary.

Everyone's Problem

Abuse is neither class nor race specific. It happens in the homes of the poor and the uneducated, the affluent, and the middle class, in expensive city condos and suburban split-levels. It occurs in preschools and day care centers.

There is no typical abuser, either. He may be middle class, middle-aged, and male. Or young and desperately poor, such as a single mother struggling to raise a family of four kids on a welfare check and child support payments that come sporadically if at all. She may be a well-to-do but lonely and deeply depressed new mother whose husband is never around to help with her premature, colicky twins, a woman who can barely get herself dressed in the morning, let alone change her babies' soiled diapers or take them to the doctor when they get sick. Each person, troubled and hurting, is unable to cope with the stresses of daily life. Possibly raised by abusive parents themselves, they may parent the way they've been parented, the only way they know how.

No one factor can be cited for the almost 50 percent increase in child abuse cases in the last decade. Rather, a number of reasons—marital discord, poverty, unemployment, a need to make hasty child-care arrangements, the isolation of today's young parents from an extended family or community where they would have had a social support group—conspire to create difficult situations that troubled parents, lacking skills, find impossible to negotiate. Although we don't know the precise correlation between childhood abuse and that person's ensuing problems in adulthood, studies strongly suggest that many victims of abuse may themselves develop abusive behavior, lack confidence and ease with their bodies. Other abused children may, as adults, have difficulty forming trusting relationships or slip into a life of crime and/or drug addiction, despite concerted efforts at parent and public education, progress in preventing child abuse remains an elusive goal.

Saving Just One

Child abuse is an under-reported crime because too many people do nothing to stop it. Children are vulnerable and powerless—too young, too scared, too uninformed, and too often ignored when they speak up on their own. As an adult, you can help an abused child. Believe what a young person tells you. Though adults may find their narratives difficult to fathom, children do not commonly make up whole stories about assault. If the child has trusted you enough to share feelings and fears about abusive situations, don't dismiss the youngster or get angry. Look at any wounds the child wants to show you and let the youngster know you are glad you were told.

Tell the child that you plan to report the problem and explain that he or she is not going to get into trouble. Report what you think you see. Call a child-abuse hotline, your state or city department of child protective services, or 911. Be prepared to give as much detail as you can, including the date and time of the alleged abuse, what you witnessed, the condition of the child, and so on. Keep in mind that the authorities are strict about maintaining confidentiality when it comes to those who file a report. If you insist on withholding your name, however, it may hinder authorities from following up. At least, even if your report is alleged to be untrue, the family is visited by a social worker.

If you think no action is being taken—and too often none is—keep calling. Contact the city or state field office responsible for following up on cases and ask what is being done to help the child.

To protect your own children, make sure to teach them that they are the bosses of their own bodies, the only ones to decide who can touch them. Of course even an appropriate hug or kiss may cause a child to squirm, but describe appropriate physical contact and explain to your child that if affection doesn't feel right, she should say no—and tell another grown-up. Tell her, too, that it's okay to say "No"—loudly—to any adult who seems about to hurt her or make her do something she is not comfortable doing. It's also okay to squirm out of an adult's grasp. Practice prevention techniques. Playing a "What if" game: "What if someone touched your private parts, tried to play a secret touching game with you" can be helpful to youngsters.

And if you see an adult mistreating a child in public? Don't give the child's parent or caregiver a dirty look or make disapproving remarks, since that could make things worse for the child and for you. Rather, sympathize with the adult's plight. You can say, "My kids used to act up just like that" or, "Kids sure can wear you down. Can I help?" Try to divert the upset adult's attention by asking questions or making small talk—anything that will distract that person and give him or her a chance to cool down. Compliment the individual, perhaps saying: "What an adorable little girl!" If the problem doesn't stop, alert a manager if you are in a store or movie theatre, for example, or the police, who have the authority to approach the parent about the problem. What's more, if you know or suspect that a parent or guardian in your community is under great duress, offer to baby sit or help with the shopping or cleaning. If you can lighten a parent's load, you'll be helping a child.

Spotting Abuse: the Warning Signs

Children who are routinely abused rarely report their agony, even to social service caseworkers. So how can you know that a child is in trouble? Pinpointing abuse is not clear-cut, but there are red flags that may alert you to potential problems. If you notice a repeated pattern of several of the following circumstances, take action:

Irritations about the mouth, genital, or anal areas; burns, marks, bruises, or injuries anywhere about the body that cannot be logically explained.

Difficulty walking, sitting, urinating, moving a hand, arm, or the neck.

Torn, stained, or bloody clothes; wearing clothes that consistently cover arms and legs, no matter how warm the day.

Abrupt changes in sleeping or eating patterns.

Regression to more infantile or childish behaviors; clinging, fear of being alone.

Self-destructive behaviors—stealing, use of drugs or alcohol, shoplifting, running away.

Repetitive play or artwork that involves sexually or violently explicit language or images that might indicate a level of knowledge beyond the child's years and exposure to TV and movies.

Change in personality—for instance, a quiet, passive child who becomes aggressive and mean, or an alert child who becomes uncommunicative or dreamy.

Across the country, grass-roots as well as state and federal organizations have established hotlines and support groups for parents and guardians who fear they may hurt their child, or for those concerned individuals who worry that a child they know is in danger. There are also organizations specifically designed to help abused children—these places not only provide therapy but they offer a nurturing, safe, and supportive environment. Through all of our efforts, we can eventually learn to assess the urgency of a situation, take constructive action—and make the world safe for everyone's children.

Perhaps the saddest legacy of abuse is the way it shatters a child's hopes for the future. Abused children often downshift into apathy and pessimism and engage in what we might call "terminal thinking." They give up on the future, like the fifteen-year-old girl, chronically abused since she was two, who, when asked what she expects to be when she is thirty, tells you "Dead." That's a tragedy—for all of us.

Female, 15 years old. **Gotcha,** 1997. Clay, each 3 x 3½ x 2½"

I think artwork is an expression beyond
imagined. My artwork has given me the
wisdom to see the truth.

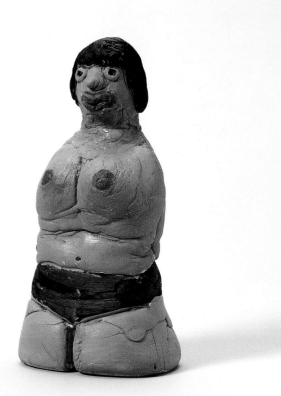

Female, 17 years old. **Self Portrait,** 1997. Acrylic on
model magic, 5½ x 3"

This artwork shows my growth in my years of
coming out of depression.

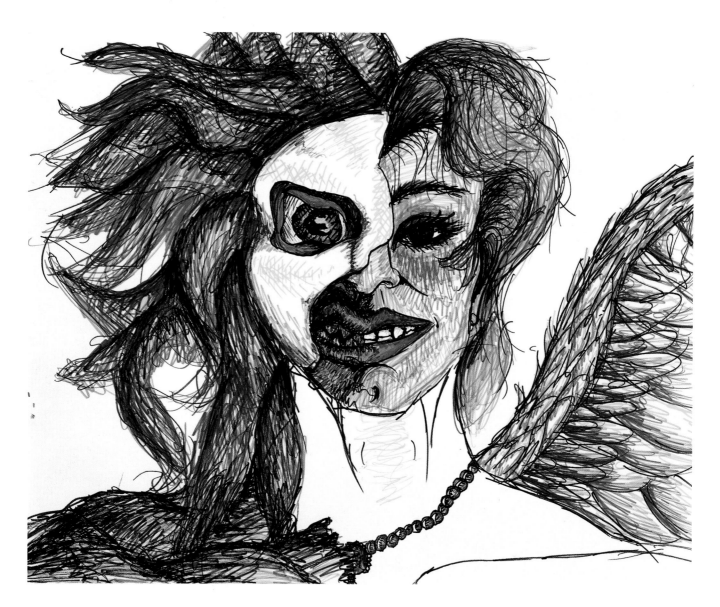

Female, 17 years old. **Untitled,** 1997. Felt markers, 14 x 17"

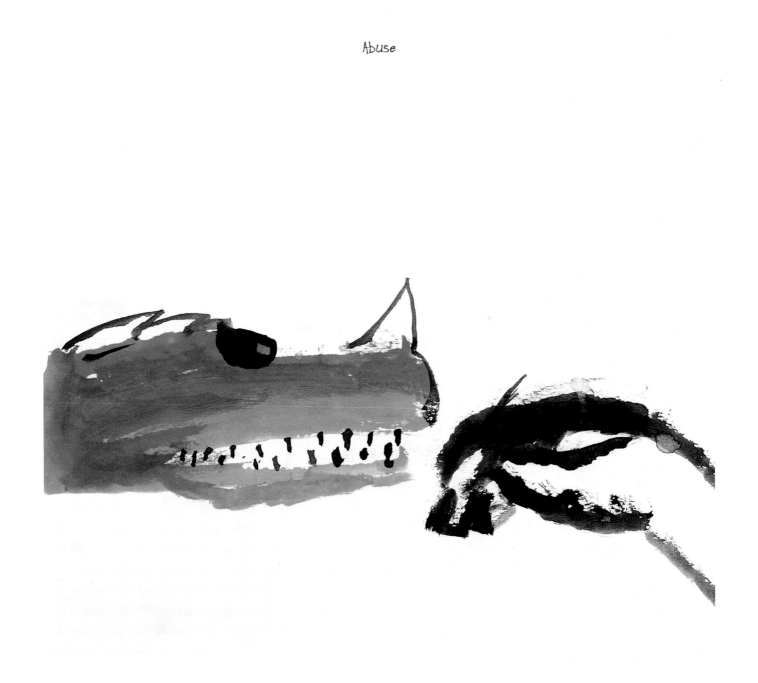

Male, 10 years old. **The Situation,** 1997. Watercolor, 7 x 12"

This picture represents how I felt when I was being bullied. The rhino is the bully and I am the snake. Being bullied felt like I was being walked over like dirt. When I did the picture I didn't know what it was about but later I remembered my problem and I knew the picture was about me.

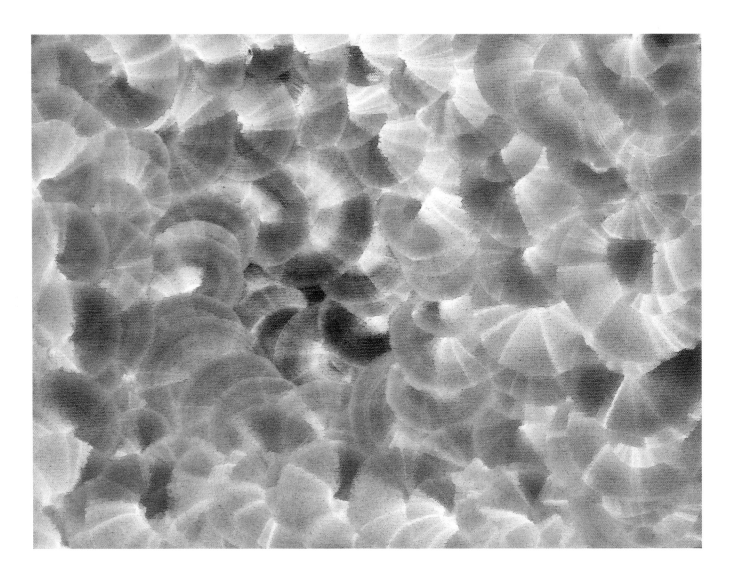

Female, 15 years old. **Confusion**, 1998. Tempera on canvas, 14 x 18"

Whatever I paint reflects on how I feel. This picture is unique—even if I did another like this, it wouldn't be the same. I can put my emotions about what happened on paper. When I see them it is nothing like saying them or thinking them. Seeing my emotions is another way of accepting them.

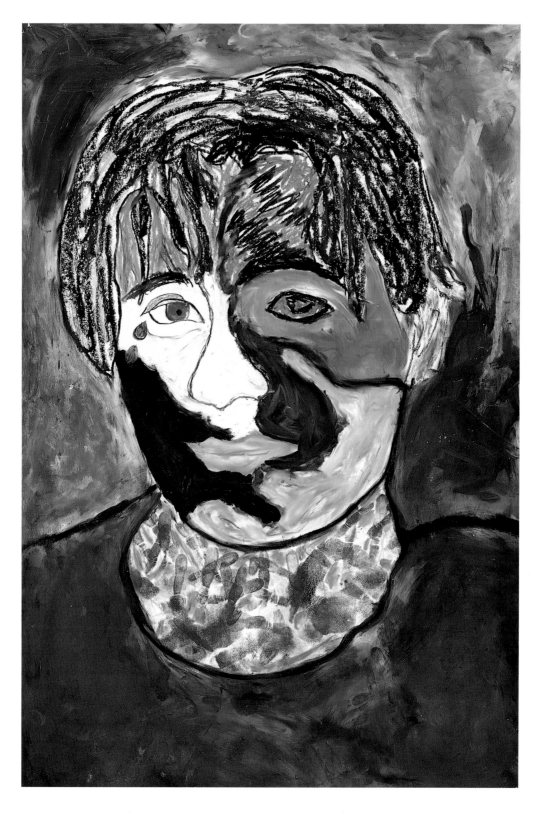

Female, 18 years old. **Camouflaged,** 1996. Oil stick, 31½ x 20½"

This piece is about me! It was the first time I ever used art
to express my feelings, I would always close up and not talk
about my feelings, but not this time. It helped me express
my pain and loneliness. I am grateful to be seen and heard.

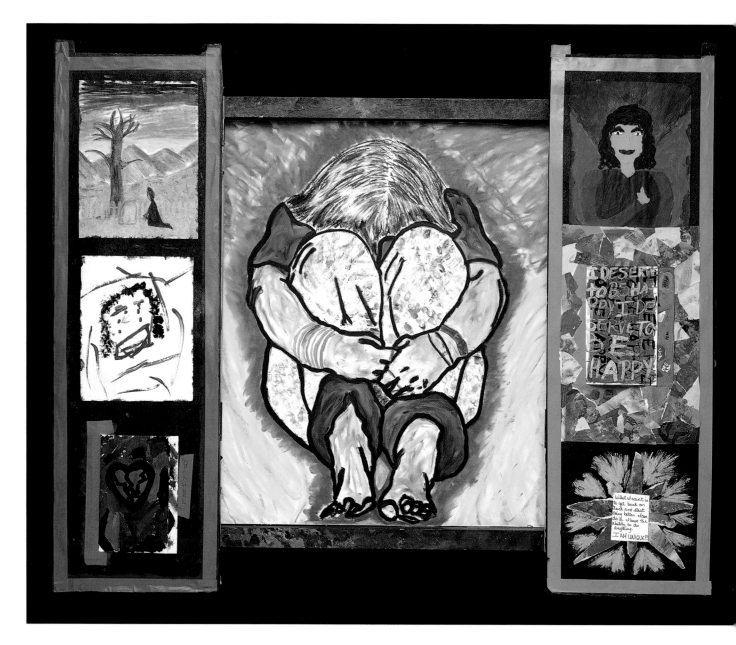

Female, 18 years old. **I Don't Know . . . I Do Know,** 1997. Oil stick, craypas, wood, collage, 35 x 42"

These shutters hide my feelings of hating myself and wanting to die. But they also show how I was able to face my fears, confusion and being scared if I was going to live. Doing this piece made me realize that I deserve to be happy and I have the strength and creativity to live.

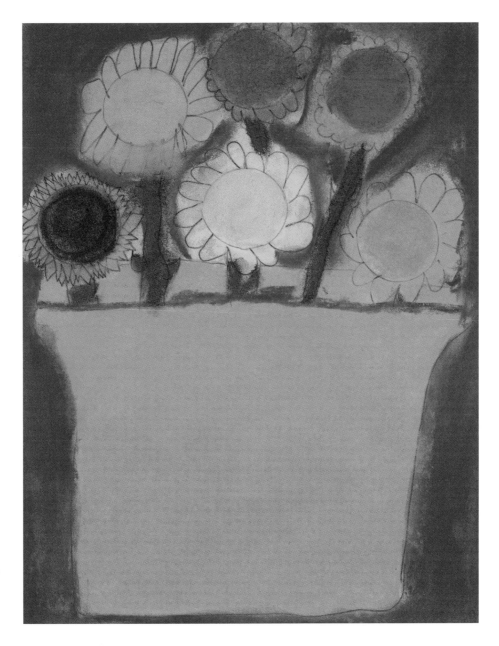

Female, 11 years old. **Flowers,** 1997. Pencil & pastel, 14 x 11"

When I came I had tantrums and felt mistrusted. I didn't like myself.
This picture is bright and shows that I feel happier and am progressing.
The flower with the brown middle shows that I still feel angry.
I have courage inside and know that I can do much better in life.
Children shouldn't feel that it is always their fault.

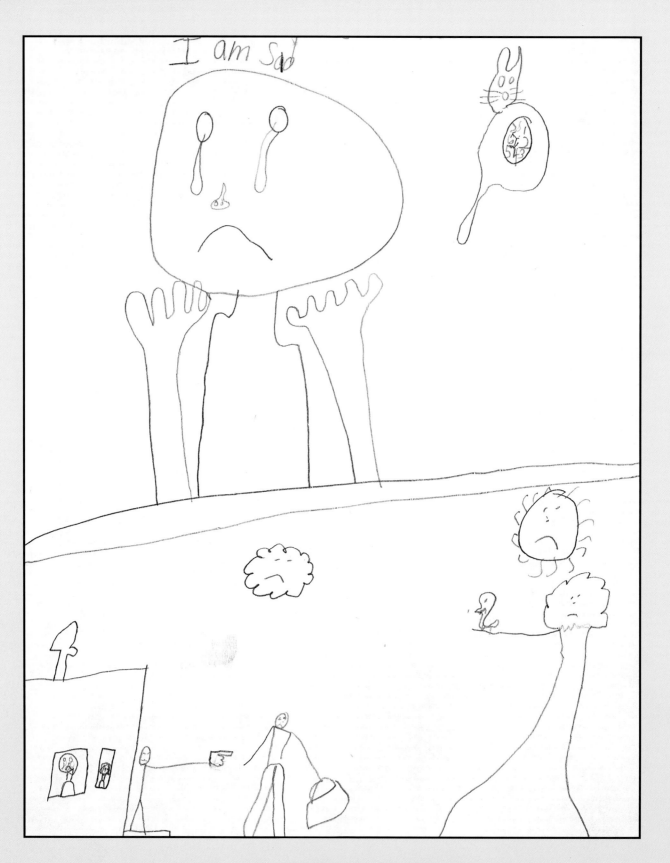

Male, 7 years old. **I Am Sad,** 1998. Pencil, 11 x 8½"

I'm crying because my dad left. And down here, I'm crying and I'm in the house and
my mom's pointing her finger at Daddy and telling him to leave. And the cloud and sun
were sad because my dad was going. A bird was sad. A tree was sad. And my sister was sad.

Divorce and Children
Broken Ties

Although everyone wants their parents to stay married, sometimes a divorce can be a blessing in disguise. I learned that two people are simply not always meant to be together just because they are married. Since the divorce, my family has grown; both parents are happily remarried and there are even more people for me to love and more to love me back. I realized it was better for me, and for my parents, to have them living happily apart rather than unhappily together.

Melissa Joan Hart, Actress, Sabrina the Teenage Witch

DESPITE WIDELY PUBLISHED REPORTS TO THE CONTRARY, DIVORCE IS NOT NECESSARILY A catastrophic event for children. Nor does it need to be the defining event that triggers for them deep and enduring suffering. More often, mental health professionals believe, a conflict-ridden marriage that preceded the divorce is the catastrophe for children. What's more, most youngsters rebound quite well from divorce. That doesn't mean they aren't sad, angry, guilt-ridden or depressed in its aftermath; indeed, it can take a year, perhaps two, for them to adjust. Although definitive long-term studies have yet to be done, it is estimated that some 20 to 25 percent of children continue to have stress-related mental health problems after divorce. But that figure must be compared to the roughly 10 percent of children in intact families who do, too. In fact, rather than painting a portrait only of depressed and overburdened youngsters, fearful of commitment and destined to face derailed relationships of their own, the most recent findings reveal that the overall emotional prognosis for children after divorce is not all that different than that of the average child in this country. Clearly, divorce ends a marriage, but it doesn't have to end a family.

Stigma Creates Stress

In fact, out of many bad marriages come good divorces. This statement is not an oxymoron. Some research shows that more than half of all couples who divorce in this country today manage to have an amicable divorce. Yet, most people, when they first face divorce themselves or hear about

a friend's crumbling marriage, immediately conjure images of a wrenching nightmare, especially if children are involved. The stories about warring spouses, deadbeat dads, and young people bearing lifelong scars, are so deeply embedded in our collective consciousness that we assume that all divorces result in such negative consequences.

At the root of many of these misconceptions are the well-entrenched beliefs that only intact families can raise emotionally healthy children, that divorcing parents are selfish, so preoccupied with their own needs and anguish that they unwittingly put their children last, that divorce is somehow abnormal. Such thinking effectively disenfranchises a huge chunk of society. When one out of every two marriages falls apart, divorce most certainly *is* the norm. Between 50 and 60 percent of the children born in the 1990s will, at some point in their lives, live in single-parent homes created by divorce. One million children experience their parents' divorce each year. It's time we acknowledge this reality and normalize the experience.

The fact that we have so few positive words, rituals, or models reflecting healthy divorced families compounds the dilemmas. Mention divorce and most of the phrases or thoughts that come to mind are negative. They are words and images that dwell on what a family or a person *lost* rather than what they *have* and *are* building for the future. Divorcing partners are inundated with information about where they went wrong, and how they shouldn't behave, but have precious few models of how they should act and react to make the necessary and appropriate transitions after a divorce.

Suppose we turn away from the stereotypical notions of divorce and embrace the idea that divorce is not necessarily a horrible, never-ending series of losses for partners or children? What if we used the term *bi-nuclear* to level the playing field and give people in this situation a positive way to describe their family that parallels the nuclear family without stigmatizing them? What if former spouses were encouraged, even expected, to maintain civility when they split? Suppose, too, that they had socially approved rituals to help them and their children cope with the end of a marriage, much like the ones we have in place when a loved one dies, rituals that would anchor them as they ride an emotional roller coaster, yet also help them to feel less alone and ostracized. What if movies, television, and first-grade readers depicted bi-nuclear families that functioned cooperatively and resolved differences amicably, instead of only nuclear families or dysfunctional families divided by painful, ugly custody disputes?

A good divorce is one in which both adults and children emerge at least as emotionally well as they were before the marriage crumbled. In a good divorce, a family remains a family — living apart, but together in terms of parenting responsibilities. That means that ex-spouses build a partnership that allows them to care for children's emotional, economic, and physical needs — a heroic feat, to be sure, but not an uncommon or impossible one.

Nevertheless, children of divorce are children at risk, in many ways like those whose parents have died. The first step in helping them cope with what's happening to their family is recognizing and dealing with the feelings and issues children generally experience at different ages when a marriage ends.

The Overriding Emotions

For many youngsters, anger and helplessness are the initial, overriding emotions. They often take sides, being angry at one parent or the other, depending on who they perceive caused the divorce. Most of all, they are frequently angry at themselves. They assume they must have been the reason for the split—or, at least, to blame for not making things better. As they watch parents remarry and form other families, their loyalties often become divided as they try to find where they fit in their parents' new lives.

Very young children fear abandonment and may be afraid that if one parent went away, the other will, too. They may cling, have difficulty falling asleep, or regress to infantile behaviors. School-age children may be more vocal in expressing anxieties and need plenty of cuddling and reassurance that they are important. Boys at this age may miss their fathers desperately and blame their mothers for ruining their lives, often becoming more aggressive and acting out in school or at home. Girls, on the other hand, may withdraw and keep their feelings inside, which can lead to low self-esteem as well as depression. Expect more stomachaches and headaches. For teenagers, divorce magnifies the tumultuous anxieties of adolescence. The already self-righteous or judgmental adolescent may lash out at a parent for disrupting his life, such as "making" him move to a new home or new school. If one or both parents begins to date or eventually remarries, teens may become even angrier and wind up not talking to one, or sometimes either, parent. They may claim that they "don't care" about what's happening around them, but don't be fooled. Teens worry deeply as they try to sort out what all this means for their parents, for themselves, and for their future relationships.

Shattering the Stereotypes

Good divorces are as varied as good marriages, but they have one important characteristic in common: the absence of malice and a deep regard for the well-being of the children. Partners maintain family relationships—including those with extended family members of the noncus-todial parent, such as grandparents, aunts, and uncles—while moving ahead with their separate lives. Children whose parents can manage this are actually happier and better adjusted than those who stay in high-conflict marriages.

Clearly, what parents say and do to prepare for divorce as well as in the post-divorce years

can ease anxieties and strengthen self-worth and confidence so that children know intuitively that while a marriage may end, their parents' love for them never does. To achieve this, keep the following advice in mind:

Let children know as many details as soon as you possibly can. Age-appropriate explanations, before a parent moves out, are crucial. When possible, both parents should tell all the children together about a decision to divorce. This conveys the sense that the decision was a rational one, arrived at regrettably but jointly as the best solution to an unhappy situation. Emphasize that this decision was made only after other options were fully explored.

Speak directly to each other about your children, not through them. Act like a grown-up—even if you don't feel like one. While it may be tempting to pour your heart out to your child, be wary of confiding too much in your children, especially your teenagers. Kids need to be treated as kids, and they shouldn't be expected to shoulder the role of parental confidante.

Acknowledge a child's sadness, guilt, and pain as well as your own. Emphasize that the children did nothing to precipitate the breakup. Don't make them think they have to hide their feelings. Expect that the classic childhood fears—of the dark, the boogeyman, of being alone, or of trying new things—will be magnified. Give children permission, too, to love each parent—to look forward to and enjoy being with each of you. Custodial parents who make it impossibly difficult for the other parent to see a child are throwing wrenches into their child's emotional healing process. Acknowledge each other's strengths as a parent—and accept the differences so you can cooperate with each other instead of constantly challenging each other.

Tell your children that life will change, and that you don't yet know exactly how or in what way. Everyday routines will shift, comforting rhythms will vanish. New changes need to be met with courage. But reassure children—repeatedly—that you will let them know as much as you can about each new situation as it develops. If they are old enough, ask them for suggestions about how to handle the new family setup. Children feel powerless after divorce, and inviting them to participate in the planning, and heeding their ideas, yields some measure of control.

Be ever-vigilant to a child's changing needs and anticipate milestones. Monitor children's reactions and how they respond to each new stage in their lives, be it a new school year, a birthday or anniversary, or a first-time summer at sleep-away camp. After a visit with a parent, does your child need a half-hour alone to readjust, or does she or he prefer to see you waiting at the door for a hug? Give them one-on-one attention, even if it's only for fifteen minutes a night. If parents remain committed and sensitive to a child's feelings and requirements, the child will grow up confident of avoiding his or her parents' mistakes.

Remember that living arrangements are a major source of stress and conflict for children. Keep in mind the developmental needs of the child. Children under five often need the security of being based in one home. After that, they are better able to handle the shift between parents' homes, and it doesn't make all that much difference how you divide their time as long as they, and their friends, know exactly where they're going, and they have their own private space once they get there.

When parents feel ill-equipped to handle a child's inner turmoil or questions, when tension and bickering between parents linger and prevent them from negotiating the inevitable changes and problems that come up, they should seek the help of a trained therapist or mediator. Good divorces don't make headlines. But many divorcing families are proving that they do make a model for children, parents, and society in general.

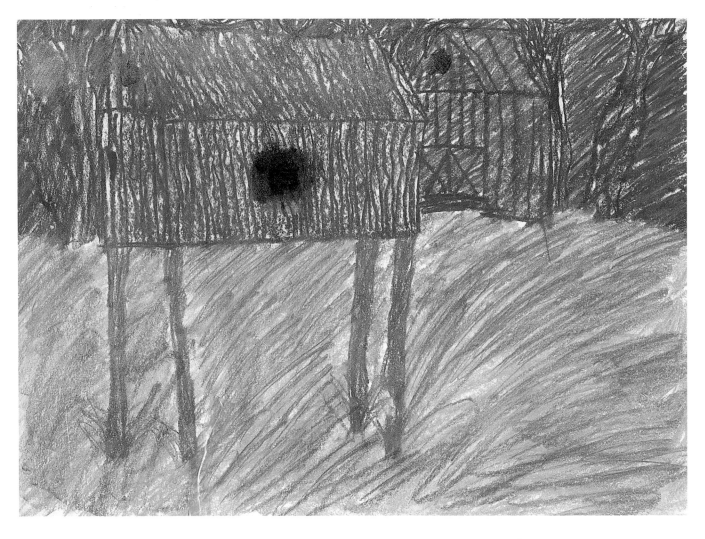

Male, 12 years old. **Untitled,** 1997. Pastel & spray paint, 18 x 24"

This house is lonely.

Female, 11 years old. **Animal Kingdoms in Divorce,** 1998. Felt markers, 4 x 9"

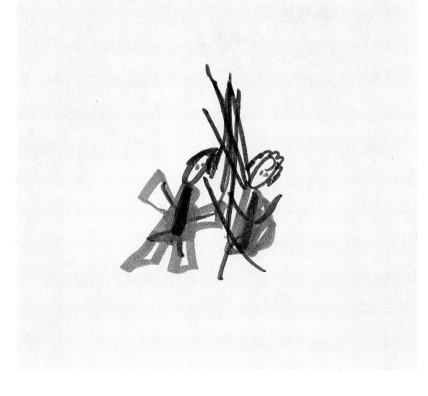

Female, 6 years old. **Untitled,** 1997.
Felt markers, 8 x 8"

This is mom and dad fighting
and fighting.

Male, 12 years old. **Lying Lawyer,** 1998. Pencil, 11 x 8"

I don't trust the court to let us not see our Dad because all lawyers
are greedy and lie to get their clients off just to make money.

Female, 14 years old. **My Scariest Memory of My Dad,** 1998. Colored pencil & graphite, 12 x 18"

My dad chased me into my room and pinned me in his arms. I couldn't breathe and I kept pleading with him to let me go but he wouldn't. He kept saying to "Shut up! What the hell's the matter with you!" My mom was screaming through the door because my Dad had his foot against the door. She was pleading with him to let me go. My sister and brother were screaming for him to stop. Finally I stopped breathing and I almost passed out. I said I was sorry. After another five minutes he let me go and slammed the door open and said "I'm out of here. Get the hell out of my way." Then he raged out the front door and didn't come back until late that night. He wouldn't talk to anyone except Jimmy for three days. Then after that time he acted like nothing happened and was questioning why I was upset.

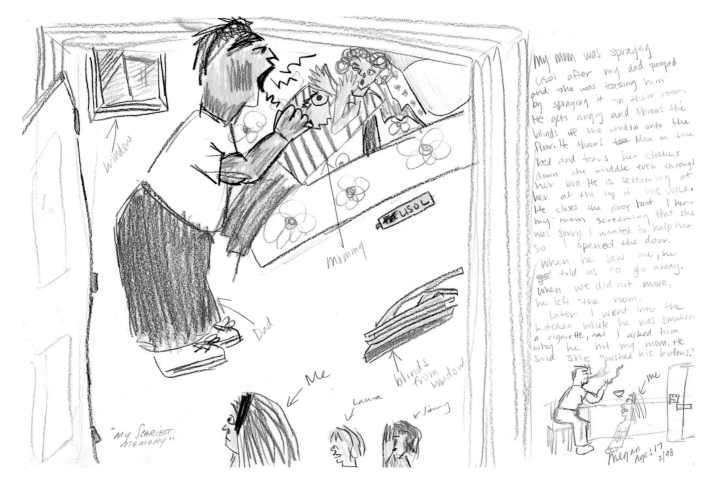

Female, 17 years old. **My Scariest Memory of My Dad,** 1998. Colored pencil & graphite, 12 x 18"

My mom was spraying Lysol after my Dad pooped and she was teasing him by spraying it
in their room. He gets angry and throws the blinds off the window onto the floor. He
throws mom on the bed and tears her clothes down the middle even through her bra.
He is screaming at her at the top of his voice. He closes the door but I can hear my mom
screaming that she was sorry. I wanted to help her so I opened the door. When he saw me he
told us to go away. when she did not move, he left the room. Later I went into the kitchen while
he was smoking a cigarette and I asked him why he hit my mom. He said she "pushed his buttons."

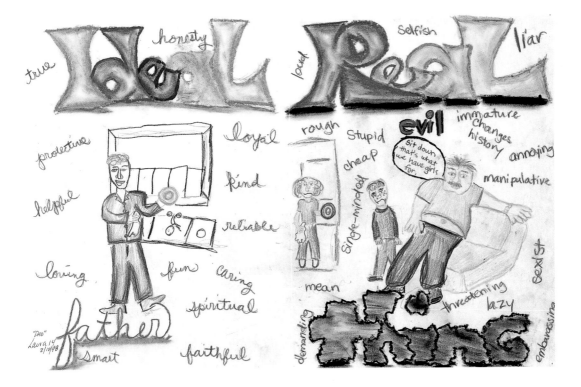

Female, 14 years old. **Ideal Dad vs. Real Dad,** 1998. Colored pencil & graphite, 12 x 18"

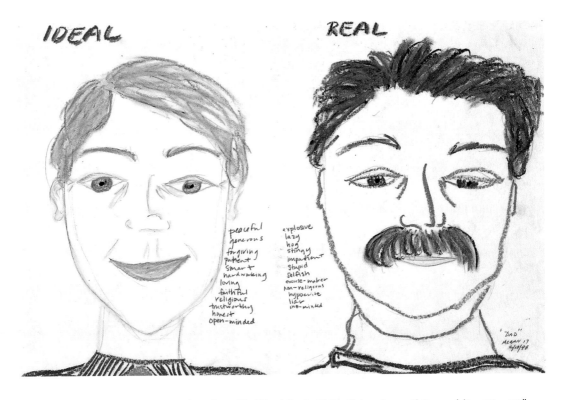

Female, 17 years old. **My Real Dad vs. My Ideal Dad,** 1998. Colored pencil & graphite, 12 x 18"

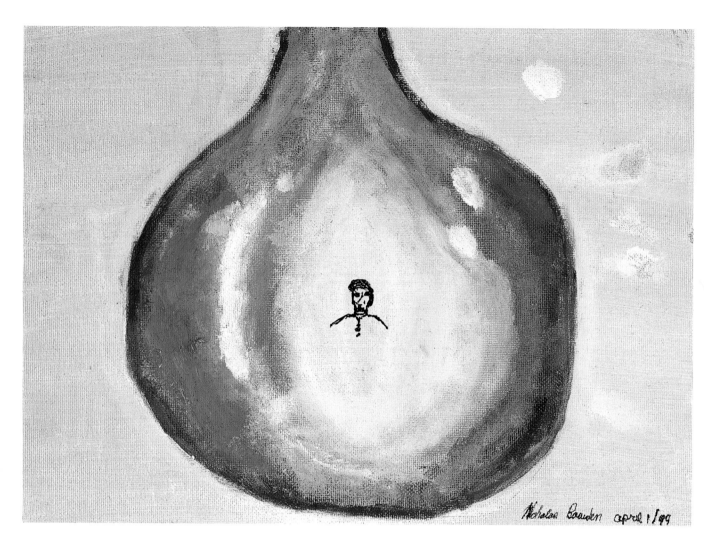

Male, 12 years old. **Sadness,** 1997. Acrylic, 9 x 12"

These paintings symbolize the explosion of feeling the feeling that shouldn't be taken lightly by any one man. I am locked in my teardrop.

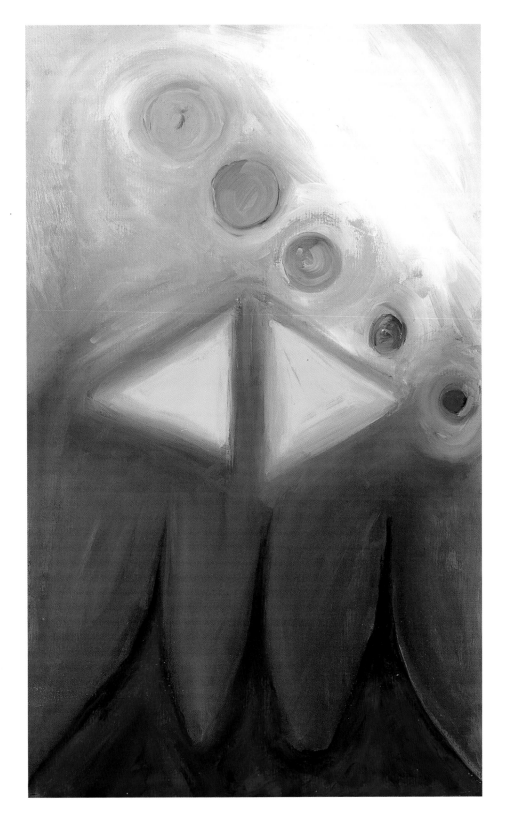

Female, 17 years old. **Thorns,** 1996. Acrylic, 4 x 3"

In this painting I'm the circles, my mom and dad are the triangles trying to keep me from death which is the thorns.

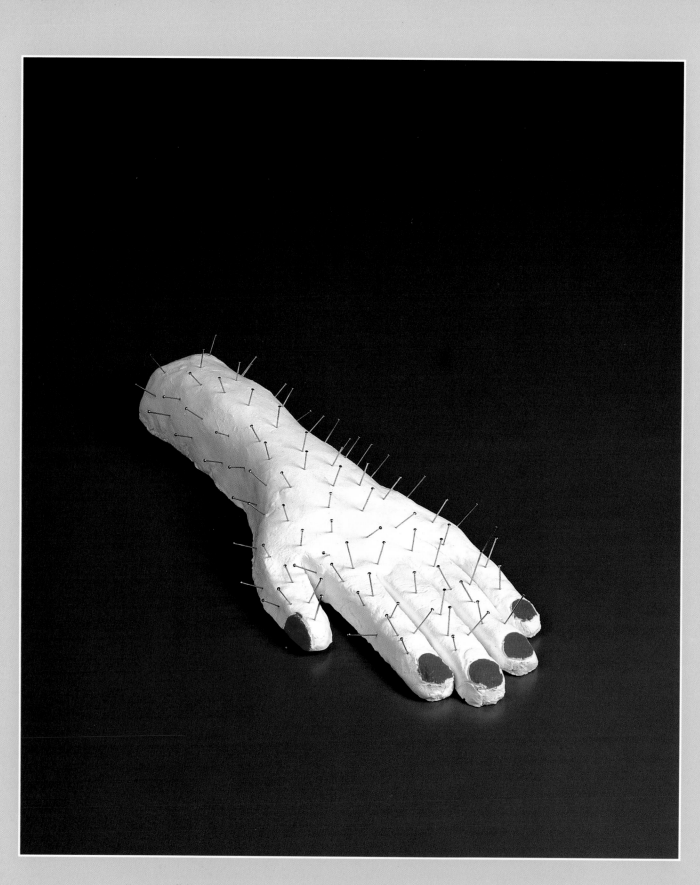

Heart condition. Female, 14 years old. **Untitled,** 1998. Clay (model magic), 12 x 4½ x 3"

I have had two heart surgeries, numerous catheratizations. My veins are very small. They always roll. Whenever the nurses do poke—the veins blow. All they do is poke me—blood draws for this and that— new IV's because the veins won't last. Then they tell me after a hundred pokes, "It's O.K., don't cry."

Physical Illness
When Kids are Chronically Ill or Disabled

Losing my leg to cancer and my hair to chemotherapy was a tremendous blow to my self-image during my adolescence. For example, I can vividly recall how embarrassed and ashamed I was whenever I took my leg off in the boys' locker room to shower after athletics. To myself, my leg looked deformed, disfigured, and disgusting. Whenever I would gain the courage to tell my teachers or my friends about my feelings, they would usually respond to me by saying, "Don't let it bother you," or "You shouldn't feel that way." As a result, I never felt like they understood how sad and upset I was. They taught me to try to forget my feelings or to dismiss them as being trivial and unimportant. One lesson I have learned from my cancer and disability is never to tell anyone that they "shouldn't feel that way." Whenever my daughter or a friend tells me about a problem that they have, I will always respond by saying, "Tell me about it," or "That must be very upsetting."

Ted Kennedy, Jr.

As ANYONE WHO HAS EVER BEEN AROUND TRULY ILL CHILDREN KNOWS, THEY SUFFER MORE THAN just their maligned physical condition—emotional and psychological pitfalls abound—and even the simplest of activities are compromised on a daily basis. How does a fourteen-year-old girl with bone cancer, whose leg is amputated above the knee, take a shower? What's it like to be that child and try on a new dress for a party, knowing how your other girlfriends will look? Or how do you arrange play dates for a four-year-old with leukemia, when nausea and a general malaise rob him of his natural spunk? And how, as parents, would you best rearrange your work or social schedules to allow time to help a fifteen-year-old with cystic fibrosis, whose lungs must be cleared of mucus every morning and evening so that he can breathe normally? Some kids, like the ten-year-old with diabetes who keeps a supply of syringes in her dresser so that she can inject herself with insulin before dinner, are able to self-administer treatment, but just imagine what inner strength and poise that requires at such a young age.

The American Academy of Pediatrics estimates that one to two million children under the age of twenty live with a chronic illness or disabling condition. Though the specifics vary widely, each child's story is alike in many ways. Each child struggles daily against pain, or with a body that doesn't work the way it's supposed to. Each is frightened, and worried about the future and the toll the illness is taking on his or her family. And, more often than not, each child has hope. For the chronically ill child, time passes in a different way than it does for the rest of us. Past and future recede as the present shifts into sharp focus. And while parents may mourn what a

child can't do, or is missing, because of his or her illness, surprisingly, most kids don't dwell on such points. Focused on today, they assume they'll get to do all those things and more—maybe a little later than they planned, but some day, for sure. Impatient at times, they are also realistic: "I'd rather not be sick," admits a seven-year-old boy recovering from a bone marrow transplant, "but you gotta do what you gotta do." "If you're 80 years old and you have a year of chemo, that's one-eightieth of your life," wisely points out another, "but if you're only 8—well, that's *one-eighth* of your life." Indeed, most chronically ill youngsters share a determination and stoicism beyond their years to make the most of the lives they have. "It's like someone pressed pause on a recorder. But it will start again," says another matter-of-factly.

Needless to say, when a child is sick, a family is thrown into turmoil. Careers, interests, sometimes even other children, are put on hold while effort and attention are concentrated on the ill child. How then can you help a child? How can you manage—alone, or with help? While there are no hard-core rules, take to heart these suggestions:

Give yourself a break. The discovery that a child has a chronic, perhaps terminal, illness is never expected and always devastating. Dreams shatter in an instant. You might feel you're on an emotional roller coaster, despairing one day, marching forward with hope and determination the next. Life becomes a struggle and the demands for reserves of emotional, spiritual, physical—not to mention financial—strength are enormous. Don't be afraid to ask for help: other parents can guide you toward a clearer understanding and acceptance of your child's disabilities and alert you to medical advances or interventions you might not have heard about; friends and family can pitch in, and medical support staff can help you keep the right perspective. Psychological advice can also help you deal with a medical crisis or a long-term condition in your family and teach you positive, emotional ways to help you cope.

Focus on strengths—yours and theirs. You can't cure a disease, but you can ease its effects. Your response to a child's illness or disability can tremendously affect his or her well-being. In so many ways, youngsters take their cues about what to think, how to behave, and who they are from the adults around them. Though it's natural to be frightened, overprotection can boomerang and lead to what experts call the "vulnerable child syndrome"—a youngster who focuses on what he can't *do rather than on what he* can *do.*

Find out what's in your control and what's not. Learn to live with the unpredictable. With a medical illness, there will be good days, weeks, or years, as well as bad. It's cru-

cial for parents and children to adjust their expectations so they can live with the unexpected. Learn what is in your power to change.

Be honest. Though guilt is cosmic for parents of a chronically sick child, it is usually no one's fault that a child is ill, but it is everyone's responsibility to find the right treatment to help him get well. Contrary to conventional wisdom, age-appropriate information about his or her illness will lessen a child's fears, not create or exaggerate them. Even the most optimistic child must endure periods of awful pain or fluctuating mood swings—some induced by medication or procedures designed to save a life or alleviate emotional fatigue. Children need doctors and parents to be clear and frank about what's happening, why, and for how long. This knowledge, presented in a calm, straightforward way, gives youngsters a measure of control, especially important when they feel helpless and powerless. Remember, in most cases, a child's own imagination broadcasts scenarios far scarier than the correct information—and when he knows what to expect about his treatment, hospital stay, symptoms, or medication, he'll be better equipped psychologically to deal with whatever curveballs life throws his way.

Reassure children, the patient, and siblings that they are not responsible for what has happened. Illogical though it may seem to a grown-up, children may be flooded by guilt that something they did, or didn't do, caused them to become sick. They wonder whether their illness resulted from disobeying you, or saying hateful things to their kid sister. Without judging, listen sympathetically and empathically to what a child says— concentrating not just on the words but also on the feelings behind the words. Help your child label his emotions—"I feel sad/frustrated/angry/envious," whatever they may be—and let him know that those feelings are important to you and nothing to be ashamed of. Art can be a wonderful way to keep those proverbial channels of communication open. A child's painting or sculpture may seem dark or disturbing—but it can be a revealing vehicle for expressing some confusing feelings, for strengthening identity, as well as for finding solace and satisfaction.

Never forget he's still a kid. Childhood continues despite a physical illness, and it's imperative for parents and physicians to be mindful of ways we can allow kids to be like their peers. "I'm tired of being special," one child with leukemia announced. "And I'm tired of people telling me I'm courageous. I just want to be like everyone else." Chronic illness affects a child's self-image, self-esteem, and his relationships with peers— after all, youngsters who spend more time in the hospital than in school may find it

difficult to maintain and sustain friendships. They may even be more comfortable with doctors and nurses than with other children. But that doesn't mean they don't worry about the things all kids fret about. They wonder: "When I go back to school, will I fit in?" "What will the others think of me?" "What can I do about my hair/my pimples/my schoolwork/my changing body?"

Teenagers, especially, are trying to figure out who they are, who they should be, and how they compare with others, and they may begin to resent what's happened to them. After all, just as their peers are loosening the parental ties and stepping toward independence, they remain tethered because of their illness. Now, more than ever, they may need a therapist, primary care physician, or contemporary who has been through a similar ordeal to supply answers to intimate questions they may be too embarrassed to ask anyone else.

Then, too, that invisible cloak of invulnerability that teens don can be more dangerous for the sick than for the healthy. Chafing at the restrictions of medical regimens or diets, adolescents may foolishly stop taking life-saving medications or skip essential treatments, convincing themselves that nothing bad will really happen. Parents must educate their children about the dangers of experimenting and taking such risks, yet be tolerant of the inevitable times when the rules will be broken or at least bent.

No one prepares you for the discovery that a child is chronically ill, or that this knowledge triggers fear, anger, and self-blame. Certainly life would be easier without myriad doctors and drugs and treatments—but it doesn't have to less rich. As these children discover—and teach us—we all have our infirmities. Some of them just happen to be physical.

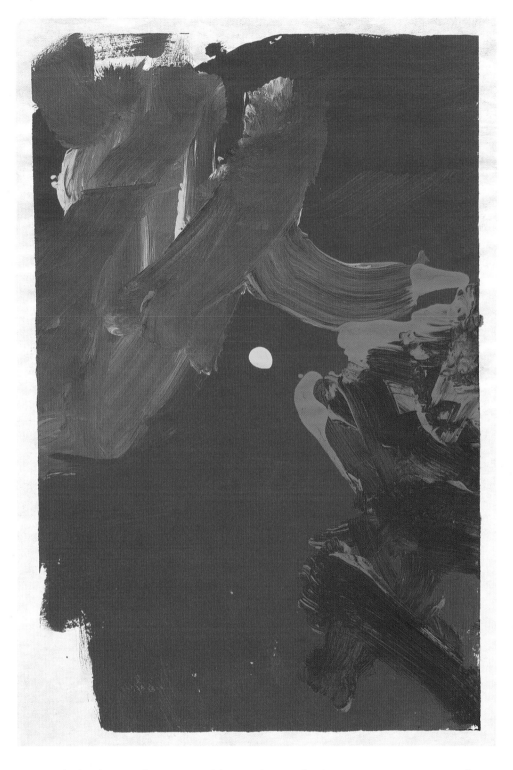

Cerebral palsy. Female, 15 years old. **Here Comes The Sun,** 1997. Tempera, 18 x 12"

I love to express myself in art. Although I am in a wheelchair and am physically limited, my art makes me feel free. It helps me grow as a person. It has been one of my greatest achievements so far.

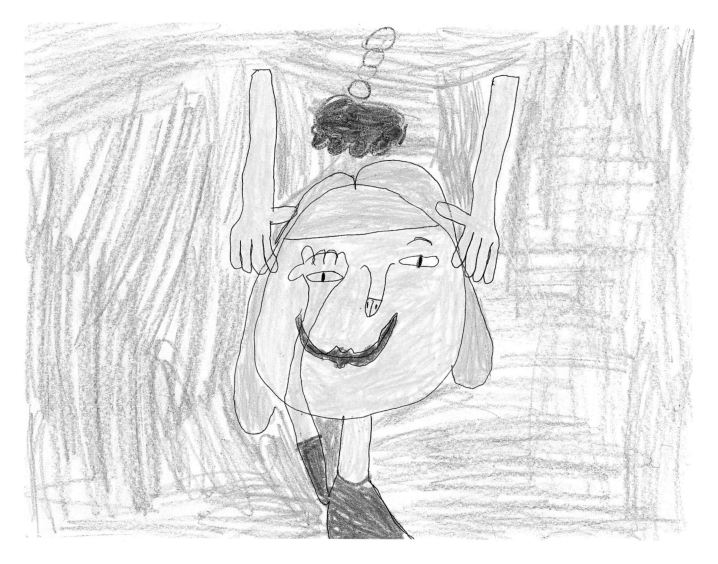

Migraine headaches. Female, 7 years old. **My Headache,** 1997. Pen & crayon, 8½ x 11"

My hand is over my left eye where my headache starts. The hands squeezing my head
are to show what the headache pain feels like. I know that when I have a headache
I am not smiling but I like to draw myself smiling so I made the smile crooked.

Heart condition. Female, 14 years old. **Untitled,** 1998. Clay (model magic), height 6½"

Because of my heart condition I am on a low sodium diet. It is even worse when I am in the hospital. I am always thirsty!! One day I could only drink 1600 cc's—6½ cups. I even try to figure out what I can order that has extra fluid in it—a can of pineapples—I can drink the juice.

Diabetes & Asthma. Male, 16 years old. **Cure vs. Dr. Flim and Diabetes King,** 1997. Pencil, 11 x 8½"

This picture represents how I feel about my illnesses. Dr. Flim, he's the type who destroys people by clogging their passageways. The Diabetes King, he just goes around the city, spreading diabetes like it's nothing. The cure is beating them up. The Cure is a karate expert. I want to be like the Cure, destroy every disease out there.

Therapist note: Flim is Phlegm, with some artistic license.

Cancer. Male, 16 years old. **Come Back,** 1997. Pencil, 12 x 18"

I feel like this picture represents me coming back to my old original self and
shocking the world. My friends and parents are witnessing my thrilling comeback on
the basketball court of life and they will see me defy the odds that have been dealt to me.

Cancer. Female, 16 years old. **Untitled,** 1998. Felt markers, 9 x 12"

The characters who are having the blowout are my "grapes." Last year I created them and I
draw them all the time. The picture describes my spectacular "Sweet 16" party I had recently.
It was so great to have a party especially for me. All of my friends came. It was great.
I had a real rough year on chemotherapy and it was definitely a treat, one I'll never forget!

Cancer. Female, 16 years old. **My Picture,** 1997. Acrylic, 11 x 14"

The first day I started working on this picture I felt really black. I mean I felt like I was nothing. But when I started putting some feeling and color to light the picture up the picture actually got me to feel so much better. I felt that there is a chance in life. And you should never give up. So you should never underestimate yourself like I did. When I drew or started this picture I thought I could never draw something. But Robin said go for it. And I actually drew a nice picture. That makes me feel better about myself. When I see this picture that I drew I feel like I want to go out and stay out and never come back. The birds bring me a lot of joy and the sun in it brightens everyday of my life. So that's how I feel and I love this picture so much.

Cancer. Male, 10 years old. **Untitled,** 1992. Felt markers, 9 x 12"

1-14-98
BY:

Blue Tears and Red Doves ✝✝

Cancer. Female, 16 years old. **Blue Tears and Red Doves,** 1998. Pencil & felt markers, 12 x 14"

Hall of Darkness
Hall of Pain
Walls of death and sorrow
Hide behind the paint
Walking down this hall of emptiness
Walking down this hollow cave
I saw four red doves flying away
I wondered why they left me
I wondered why they couldn't stay
While walking down this "nothing" path
I felt all alone and irate/ Blue tears fell from my eyes
In a blue hall I was left to die
I held it in and wiped my eyes
I picked myself up and walked what felt like a thousand miles
When to my surprise I saw a light
It was the end of the hall
It was the doorway to life/I had finally felt free again
I had finally felt alive
I will never forget my journey and those four red doves of mine
For now we are binded together
Together 4ever till the end of time.

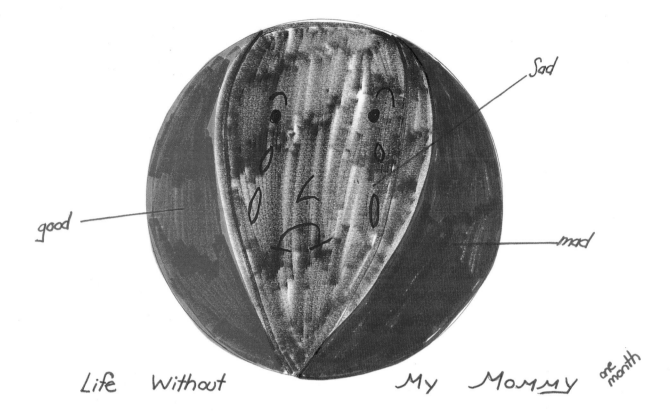

good

Sad

mad

Life Without My Mommy one month

HIV. Female, 9 years old. **Mandala,** 1997. Felt markers, 11 x 17"

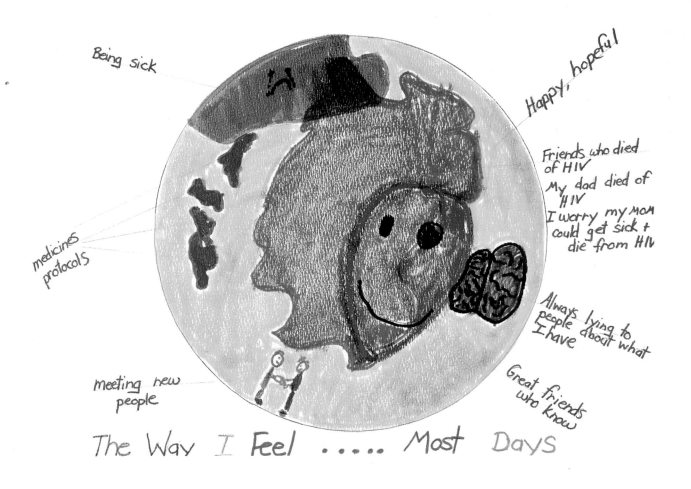

The Way I Feel Most Days

Being sick

Happy, hopeful

Friends who died
of HIV

My dad died of
HIV

I worry my mom
could get sick +
die from HIV

medicines
protocols

Always lying to
people about what
I have

meeting new
people

Great friends
who know

HIV. Male, 10 years old. **Mandala,** 1997. Felt markers, 11 x 17"

Consultants

Constance Ahrons, Ph.D.
Divorce
Professor of Sociology and Director of the Marriage and Family Therapy Program at the University of Southern California. She is the author of *The Good Divorce,* which was published in a new edition by HarperCollins in 1998. Dr. Ahrons is currently directing a follow-up to her major national study of 98 families twenty years after a divorce. In addition to her teaching, research, and writing, Dr. Ahrons has a private therapy and mediation practice in Santa Monica, California.

Anne Marie Albano, Ph.D.
Anxiety Disorders
Assistant Professor of Psychiatry, New York University School of Medicine and Director of the Children's Anxiety Service, NYU Child Study Center. Her program, School Smarts, is used by educators nationwide to help separation-anxious children who are fearful of school.

Gabrielle Carlson, M.D.
Depression
Professor of Psychiatry and Pediatrics and Director of the Division of Child and Adolescent Psychiatry, State University of New York at Stony Brook, School of Medicine. Dr. Carlson's landmark study of depression in children and adolescents was one of the first to draw attention to this long-overlooked problem.

Howard Gardner, Ph.D.
Learning Differences
Hobbs Professor of Cognition and Education and Co-Director, Project Zero, Harvard Graduate School of Education. His pioneering book, *Multiple Intelligences: The Theory in Practice,* is changing the course of education today and affecting children everywhere.

Robin F. Goodman, Ph.D., A.T.R.-BC
Physical Illness
Clinical Assistant Professor, Department of Psychiatry, New York University Medical Center, first Behavioral Health Team leader of Pediatric Hematology Oncology. Dr. Goodman's work with parents and children, coupled with her background as past president of the American Art Therapy Association, places her in the forefront of initiatives promoting psychological and physical health.

Edward M. Hallowell, M.D.
Attention Deficit Hyperactivity Disorder
Child and Adolescent Psychiatrist, Instructor of Psychiatry at Harvard Medical School, Director of the Hallowell Center for Cognitive and Emotional Health in Concord, Massachusetts. Dr. Hallowell is co-author of *Driven to Distraction,* one of the first books to explain that ADHD is not only a common problem but a lifelong one.

David Herzog, M.D.
Eating Disorders
Executive Director of the Harvard Eating Disorders Center and Professor of Psychiatry at Harvard Medical School. An internationally recognized expert, Dr. Herzog is also the principal investigator for a ten-year, ongoing study of eating disorders funded by the National Institute of Mental Health.

Eric Hollander, M.D.
Pervasive Developmental Disorders and Autism
Professor of Psychiatry and Clinical Director of the Seaver Autism Research Center at Mount Sinai School of Medicine, New York. The Seaver Center for Autism and Research Treatment, the largest and most comprehensive research and treatment facility for autism in the world, is dedicated to unraveling the biological causes of autism and related pervasive developmental disorders, and to developing effective treatment options for autism.

Stanley Kutcher, M.D.
Psychosis
Professor and Head of Psychiatry at Dalhousie University and Psychiatrist in Chief, Queen Elizabeth II Health Sciences Centre in Nova Scotia. One of the world's foremost experts in psychopharmacology, Dr. Kutcher's work has revolutionized the treatment of seriously disturbed youngsters.

Bruce D. Perry, M.D., Ph.D.
Post-Traumatic Stress Disorder
Thomas S. Trammell Research Professor, Department of Child Psychiatry, Baylor College of Medicine and Chief of Psychiatry at Texas Children's Hospital. Dr. Perry headed the trauma team that treated the Branch Davidian children in Waco, Texas, and directs CIVITAS Child Trauma Programs at Baylor College of Medicine, training educators and mental health professionals to work with maltreated children.

Lenore Terr, M.D.
Abuse
Clinical Professor of Psychiatry, University of California, San Francisco. Dr. Terr's pioneering work with the twenty-six children who survived the infamous Chowchilla, California, school bus kidnapping, in 1976, provides a baseline for helping to ease the psychological effects of physical and emotional trauma.

National Mental Health Resources

Depression

Depression and Related Affective
Disorders Association
Meyer 3-181
600 N. Wolfe Street
Baltimore, Md. 21287-7381
Phone: (401) 955-4647 or
 (202) 955-5800
www.med.jhu.edu/drada

Unites the efforts of persons with affective disorders, family members, and mental health professionals. Its mission is to alleviate the suffering arising from depression and manic depression by assisting self-help groups, providing education and information, and lending support to research programs. Publications and educational videotapes are available.

National Depressive and Manic
Depressive Association
730 N. Franklin Street, Suite 501
Chicago, Ill. 60610-3526
Phone: (800) 826-3632
www.ndmda.org

This organization's mission is to educate patients, families, professionals, and the public about the nature of major depressive disorder and bipolar disorder/manic depressive illness. It works to foster self-help for patients and their families, eliminate discrimination and stigma, improve access to care, and advocate for research. It publishes a newsletter and holds a conference annually.

National Foundation for Depressive
Illness, Inc.
P.O. Box 2257
New York, N.Y. 10116-2257
Phone: (800) 248-4344
www.depression.org

Dedicated to correcting the myths and misinformation surrounding depression and manic depression. The group provides
information about the symptoms, course, and treatment of these illnesses, including doctor and support-group referrals. It publishes a quarterly newsletter and disseminates information packets.

Eating Disorders

American Anorexia Bulimia
Association, Inc.
165 W. 46th Street, Suite 1108
New York, N.Y. 10036
Phone: (212) 575-6200
www.aabainc.org

Dedicated to the prevention and treatment of eating disorders through advocacy, education, and research. It offers a nationwide referral service for patients and their families to locate support groups, treatment centers, and therapists specializing in this field.

Eating Disorders Awareness and
Prevention
603 Stewart Street, Suite 803
Seattle, Wash. 98101
Phone: (206) 382-3587
members.aol.com/edapinc

This group works to increase the awareness and prevention of eating disorders through advocacy, education, and the dissemination of materials. It provides information about treatment options, publishes a quarterly newsletter, and organizes the annual Eating Disorders Awareness Week.

Harvard Eating Disorders Center
356 Boylston Street
Boston, Mass. 02116
Phone: (617) 236-7766
www.hedc.org

This center is dedicated to research and education about eating disorders and their detection, treatment, and prevention. It finances research, develops professional
training, creates curricula for school-based prevention programs, and increases public awareness through education and outreach.

National Association of Anorexia
Nervosa and Associated Disorders
Box 7
Highland Park, Ill. 60035
Phone: (847) 831-3438
members.aol.com/anad20/index.html

Provides counsel and information to individuals with eating disorders, and to their families and health professionals. Its services include a hotline, national referrals to therapists, and assistance with the formation of support groups. It publishes a newsletter and organizes conferences, seminars, and lectures.

Anxiety Disorders

Anxiety Disorders Association of
America
11900 Parklawn Drive, Suite 100
Rockville, Md. 20852
Phone: (301) 231-9350
www.adaa.org

Promotes the prevention and cure of anxiety disorders and works to improve the lives of people who suffer from them. It disseminates books, publications, and tapes, and provides listings of self-help/ support groups as well as referrals to treatment providers nationwide.

National Institute of Mental Health
Anxiety Disorders Education Program
Phone: (800) 888-8ANXIETY
 [(800) 826-9438]
www.nimh.nih.gov/anxiety

This national education campaign works to increase awareness of anxiety disorders, their symptoms, and their treatment; decrease the stigma about anxiety and other mental disorders; and encourage

people to seek help. It disseminates a variety of written materials as well as educational videos.

Obsessive-Compulsive Foundation, Inc.
P.O. Box 70
Milford, Conn. 06460-0070
Phone: (203) 878-5669
www.ocfoundation.org

Educates the public and professional communities about OCD and related disorders; provides assistance to individuals with OCD and to their family and friends; and supports research into the causes of OCD and effective treatments. It organizes support groups and makes professional referrals nationwide. It publishes a bimonthly newsletter for families (The OCD Newsletter), a semiannual newsletter for and by kids (Kidscope), and a videotape called "The Touching Tree," which describes OCD to children.

Psychosis

National Alliance for Research on
Schizophrenia and Depression
60 Cutter Mill Road, Suite 404
Great Neck, N.Y. 11021
Phone: (516) 829-0091
www.mhsource.com/narsad.html

This organization raises and distributes funds for scientific research into the causes, cures, treatments, and prevention of brain disorders, primarily schizophrenia and depression. It provides information packages to patients and their families.

Attention Deficit Hyperactivity Disorder

Children and Adults with Attention
Deficit Disorders (CH.A.D.D.)
499 N.W. 70th Avenue, Suite 101
Plantation, Fla. 33317
Phone: (800) 233-4050 or
 (954) 587-3700
www.chadd.org

Provides support and information to families with children with ADD and ADHD, and assists parents and others interested in starting support groups. It holds an annual conference and publishes both a magazine and quarterly newsletter.

Learning Differences

The International Dyslexia Association
8600 LaSalle Road
Chester Building, Suite 382
Baltimore, Md. 21286-2044
Phone: (800) ABCD123 or
 (410) 296-0232
www.interdys.org

Furnishes information and referral services to children with dyslexia and to their families regarding diagnosis and tutoring, schools, effective teaching methods, recent research, and assistive technologies. It conducts conferences, seminars, and support groups.

Learning Disabilities
Association of America
4156 Library Road
Pittsburgh, Pa. 15234
Phone: (412) 341-1515
www.ldanatl.org

Offers parents access to support groups and educational meetings; works directly with the schools to better serve children with learning disabilities; and teaches parents how to advocate on behalf of their children. Members receive Newsbriefs, its national newsletter, published six times a year.

National Center for Learning Disabilities
381 Park Avenue South, Suite 1401
New York, N.Y. 10016
Phone: (888) 575-7373 or
 (212) 545-7510
www.ncld.org

Provides information on learning disabilities and resources, including local referrals to schools, clinics, camps, colleges, and

parent-support groups. It offers outreach and education through seminars, a magazine, newsletters, and a video kit. Every Child is Learning *is a program to help preschool teachers and parents recognize warning signs of learning disabilities.*

National Institute of Child Health and
Human Development
National Institutes of Health
31 Center Drive
MSC 2425, Building 31, Room 2A32
Bethesda, Md. 20892-2425
Phone: (800) 370-2943
www.nih.gov/nichd

This federal government agency conducts and supports research to maintain the health of children, adults, families, and populations. It has a program to investigate learning disorders and a publication on reading disability entitled Why Children Succeed or Fail at Reading.

Pervasive Developmental Disorders and Autism

Autism Research Institute
4182 Adams Avenue
San Diego, Calif. 92116
Phone: (619) 281-7165
www.autism.com/ari

Conducts research on the causes of autism and on methods of preventing, diagnosing, and treating autism and other severe behavioral disorders of childhood. Research results are disseminated to parents and professionals worldwide through its quarterly newsletter.

Autism Society of America
7910 Woodmont Avenue
Suite 650
Bethesda, Md. 20814-3015
Phone: (800) 328-8476
www.autism-society.org

The mission of this organization is to promote lifelong access and opportunities for persons within the autism spectrum and

their families so that they can be included as members of their communities through advocacy, public awareness, education, and research related to autism. It publishes a newsletter, holds an annual conference, and offers autism information packages.

National Alliance for Autism Research
414 Wall Street, Research Park
Princeton, N.J. 08540
Phone: (888) 777–NAAR
www.naar.org

Dedicated to funding and accelerating biomedical research into the causes, treatment, prevention, and cure of autism and related disorders. It publishes a newsletter, sponsors conferences, and engages in advocacy efforts.

Post-Traumatic Stress Disorder

American Red Cross
Disaster Mental Health Services
Attn: Public Inquiry Office, 6th Floor
8111 Gatehouse Road
Falls Church, Va. 22042
Phone: (703) 206–7090
redcross.org/disaster/services/health.html

Primary focus is on the emotional well-being of individuals affected by disaster. It provides licensed, trained professional mental health practitioners who offer crisis counseling to disaster victims. The practitioners are trained to recognize the emotional impact of a disaster.

CIVITAS ChildTrauma Programs
www.civitas.org

The CIVITAS ChildTrauma Programs have been created as a partnership between Texas Children's Hospital, Baylor College of Medicine, and CIVITAS Initiative, a national organization based in Chicago and Houston. The mission of CIVITAS Initiative is to create a child-literate society. CIVITAS Initiative creates collaborative

partnerships with individuals, organizations, and agencies to design and distribute innovations in assessment, information management, service delivery, and education. The site contains information on special projects, including materials on child development and maltreatment.

David Baldwin's Trauma Information Pages
www.trauma-pages.com

This web site provides information, research, articles, and resources relating to emotional trauma and traumatic stress, including post-traumatic stress disorder. Information is applicable to clinicians and researchers as well as to individuals.

Sidran Foundation
2328 W. Joppa Road, Suite 15
Lutherville, Md. 21093
Phone: (410) 825–8888
www.sidran.org

This national nonprofit organization is devoted to education, advocacy, and research related to the early recognition and treatment of trauma-related stress in children, and the understanding and treatment of adults suffering from trauma-generated disorders. Sidran publishes books and educational materials, and provides resources and referrals to callers. It has developed education workshops on the psychological outcomes of severe childhood trauma for a variety of audiences, including adult survivors, their partners, caregivers of abused children, and non-clinical professionals.

Abuse

Childhelp USA National Child Abuse Hotline
Phone: (800) 4–A–CHILD
　　　[(800) 422–4453]

This hotline provides crisis counselors 24 hours a day to meet the needs of both

children and parents. It offers crisis intervention, information regarding child abuse, parenting, and other related issues. It provides referrals to agencies across North America.

Kempe Children's Center
1825 Marion Street
Denver, Colo. 80218
Phone: (303) 864–5252
www.kempecenter.org

This center provides a clinically based resource for training, consultation, program development and evaluation, and research on all forms of child abuse and neglect. It is committed to multidisciplinary approaches to improve the recognition, treatment, and prevention of all forms of abuse and neglect. Publications and audio-visual materials are available.

National Clearinghouse on Child Abuse and Neglect Information
330 C Street, SW
Washington, D.C. 20477
Phone: (800) 394–3366
www.calib.com/nccanch

This is a national resource for the public and professionals seeking information on the prevention, identification, and treatment of child abuse and neglect, and related child welfare issues. It disseminates written materials and referrals to organizations nationwide.

National Committee to Prevent Child Abuse
200 S. Michigan Avenue, 17th Floor
Chicago, Ill. 60604
Phone: (312) 663–3520
www.childabuse.org

The mission of this volunteer-based organization is a nationwide commitment to prevent child abuse. It strives to ensure that all new parents have access to resources necessary to care for themselves and their children, and through its Healthy Families America seeks to establish a

volunteer home visitor system for new parents nationwide. It disseminates information to create child abuse prevention strategies, programs, and policies.

Divorce

American Association for
Marriage and Family Therapy
1133 15th Street, NW, Suite 300
Washington, D.C. 20005-2710
Phone: (202) 452-0109
www.aamft.org

This group represents the professional interests of more than 23,000 marriage and family therapists. It works to increase understanding, research, and education in the field of marriage and family therapy, and to ensure that the public's needs are met by trained practitioners. It offers informative brochures and pamphlets.

National Council on Family Relations
3989 Central Avenue NE
Suite 550
Minneapolis, Minn. 55421
Phone: (888) 781-9331
www.ncfr.com

This group's mission is to provide a forum for family researchers, educators, and practitioners to share in the development and dissemination of knowledge about families and family relationships, establish professional standards, and promote family well-being.

Physical Illness

Academy of Pediatrics
141 Northwest Point Boulevard
Elk Grove Village, Ill. 60007
Phone: (847) 981-7941
www.aap.org

This organization consists of 54,000 primary care pediatricians, pediatric medical subspecialists, and pediatric surgical spe-

cialists dedicated to the health, safety, and well-being of infants, children, adolescents, and young adults. It provides information on a variety of child and adolescent health topics.

Association for the Care of
Children's Health
19 Mantua Road
Mt. Royal, N.J. 08061
Phone: (800) 808-ACCH or
 (609) 224-1742
www.acch.org

This group includes parents and professionals in a united effort through practice and policy to affect positive outcomes and high standards in the care of children and their families. It achieves its mission through education, research, advocacy, and development and dissemination of resource materials. Its Pediatrics Pain Awareness Initiative is intended to raise awareness of existing tools and techniques for managing children's pain and advances that need to be made in this field.

National Cancer Institute
Cancer Information Service
Phone: (800) 4-CANCER
 [(800) 422-6237]
www.nci.nih.gov

The Cancer Information Service is the voice of the National Cancer Institute for patients, their families, the general public, and professionals. Information specialists provide each caller with thorough, personalized attention about cancer prevention, screening, detection, diagnosis, treatment, and research.

General Resources

American Academy of Child and
Adolescent Psychiatry
3615 Wisconsin Avenue, NW
Washington, D.C. 20016-3007
Phone: (202) 966-7300
www.aacap.org

The Academy represents over 6,700 child and adolescent psychiatrists who actively research, diagnose, and treat psychiatric disorders affecting children and adolescents and their families. It publishes Facts for Families, informational sheets on a variety of psychiatric disorders to help educate parents and families. It provides free referrals to child and adolescent psychiatrists nationwide.

American Association of Psychiatric
Services for Children
Child Welfare League of America
440 First Street, NW, 3rd Floor
Washington, D.C. 20001-2085
Phone: (202) 942-0295
www.cwla.org

This group's goals include advancing knowledge about mental health care issues facing children; improving the quality and standards of mental health services delivered to children; and promoting prevention. It disseminates information and has a range of publications for children.

American Psychiatric Association
1400 K Street, NW
Washington, D.C. 20005
Phone: (202) 682-6220
www.psych.org

This professional organization has more than 40,000 physician members who specialize in the diagnosis and treatment of mental and emotional illness as well as substance use disorders.

American Psychological Association
750 First Street, NE, Suite 700
Washington, D.C. 20002-4241
Phone: (202) 336-5500
www.apa.org

Consists of more than 155,000 researchers, educators, clinicians, consultants, and students who work to advance psychology as a science, as a profession, and as a means of promoting human welfare. It promotes research, establishes and maintains stan-

dards of professional ethics and conduct, and disseminates information.

Child, Adolescent and Family Branch
Center for Mental Health Services
5600 Fishers Lane, Room 18–49
Bethesda, Md. 20857
Phone: (301) 443–1333 or
 (800) 789–2647
www.mentalhealth.org/child

This government organization supports the development of accessible and appropriate home- and community-based mental health services for children and adolescents with serious emotional disturbance and for their families. It offers grants to groups working in the field of children's mental health, including family members. Its Knowledge Exchange Network provides information and resources on prevention, treatment, and rehabilitation services for mental illness.

Federation of Families for Children's
Mental Health
1021 Prince Street
Alexandria, Va. 22314–2971
Phone: (703) 684–7710
www.ffcmh.org

This parent-run organization focuses on the needs of children and youth with emotional, behavioral, or mental disorders and their families. It provides information and engages in advocacy regarding research, prevention, early intervention, family support, education, transition services, and other services needed by children, youth, and their families.

Information Resources and Inquiries
Branch Office of Scientific Information
National Institute of Mental Health
5600 Fishers Lane,
Room 7C–02, MSC 8030
Bethesda, Md. 20857
Phone: (301) 443–4513
www.nimh.nih.gov

The National Institute of Mental Health

conducts and supports research that seeks to foster better understanding, diagnosis, treatment, rehabilitation, and prevention of mental illness. The Information Resources and Inquiries Branch responds to calls and requests for written materials about a variety of mental disorders, including anxiety disorder, attention deficit disorder, autism, depression, eating disorders, panic disorder, post-traumatic stress disorder, and schizophrenia.*

National Alliance for the Mentally Ill
200 N. Glebe Road, Suite 1015
Arlington, Va. 22203–3754
Phone: (800) 950–NAMI or
 (703) 524–7600
www.nami.org

A grass-roots self-help group that offers support and advocacy to families and friends of people with severe mental illnesses. It provides education about brain disorders, supports increased funding for research, and advocates for adequate health insurance, housing, and rehabilitation. It also makes referrals to local NAMI affiliates.

The National Association of
Social Workers
750 First Street, NE, Suite 700
Washington, D.C. 20002–4241
Phone: (202) 408–8600
www.naswdc.org

This group promotes, develops, and protects the practice of social work and social workers. With more than 155,000 members, it seeks to enhance the well-being of individuals, families, and communities through its work and advocacy efforts.

National Mental Health Association
1021 Prince Street
Alexandria, Va. 22314–2971
Phone: (800) 433–5959
www.nmha.org

Dedicated to improving mental health, preventing mental disorders, and achieving

victory over mental illness. It partners with more than 330 affiliates nationwide to accomplish this mission through advocacy, public education, research, and service. Its local chapters provide information and support for families and assists them in helping family members. The national organization publishes pamphlets and booklets on all aspects of mental health and mental illnesses. It has a special series dealing with children's feelings.*

NYU Child Study Center
550 First Avenue
New York, N.Y. 10016
Phone: (212) 263–6622
Fax: (212) 263–0990
www.nyuchildstudycenter.org

The NYU Child Study Center is dedicated to the understanding, prevention, and treatment of child and adolescent mental health problems, utilizing the facilities and resources of the world-class NYU School of Medicine. The Center's three-part mission is to integrate comprehensive patient care with state-of-the-art research and training. The Center's scientists are at the forefront of psychiatric research in prevention and multimodal treatments. The Center offers expert psychiatric services for children and families, with an emphasis on early identification and intervention. Program specialists translate scientific developments and innovative procedures into everyday techniques and strategies for parents, educators, pediatricians, and mental health professionals. The NYU Child Study Center aims to set the highest standards in promoting clinical services, research, and training in children's mental health. It publishes the NYU Child Study Center Letter five times a year for mental health professionals, educators, and others working with children and adolescents.

Participating Clinicians and Teachers and Their Affiliations

The following individuals submitted the artwork reproduced in this book

Depression

Mary Pringle Blaylock, A.T.R., M.S.T.
North County Interfaith Counseling
Escondido, Calif.

Doris J. Chuang, M.A.
St. Luke's—Roosevelt Hospital Center
New York, N.Y.

Judith A. Howard, Ph.D.
Behavioral Health Associates
Ruston, La.

P. Gussie Klorer, Ph.D., A.T.R.-BC
Southern Illinois University at
Edwardsville
Edwardsville, Ill.

Jannette McMenamy, M.A.
University of Massachusetts Memorial
Medical Center
Department of Developmental &
Behavioral Pediatrics
Worcester, Mass.

**Anita Mester, M.A., A.T.R.-BC, LPPC,
LCDC**
Children's Medical Center of Dallas
Dallas, Tex.

Amy Rogers, MFCCI
Seneca Center
Hayward, Calif.

Diane Safran, A.T.R.-BC, LMFT
Attention Deficit Disorders Institute
Westport, Conn.

Eating Disorders

Lisa S. Fliegel, M.A.A.T.
Arts Incentive Program
McLean Hospital
Belmont, Mass.

**Amy Haus, M.A., A.T.R.-BC, and
Ellis Eisner**
Mount Sinai—New York University
Medical Center and Health System
Department of Psychiatric
Rehabilitation
New York, N.Y.

Lisa C. Kaufman, B.F.A., M.A.A.T.
Hackensack University Medical Center
Department of Psychiatry and
Behavioral Medicine—Adolescent
Partial Hospital Program
Hackensack, N.J.

Nina J. Serpiello,
Lucile Packard Children's Health Services
at Stanford
Palo Alto, Calif.

Sheryl Stern, M.A., A.T.R.
North Shore University Hospital
Center for Eating Disorders
Manhasset, N.Y.

Anxiety Disorders

Lisa S. Fliegel, M.A.A.T.
Arts Incentive Program
McLean Hospital
Belmont, Mass.

**Lisa Kay, A.T.R.-BC, LCPC, and
Pat Quinn, A.T.R.**
Catholic Children's Home
Special Education School
Alton, Ill.

Eva Lebovic
Mount Sinai Medical Center
Miami Beach, Fla.

Jannette McMenamy, M.A.
University of Massachusetts Memorial
Medical Center
Department of Developmental &
Behavioral Pediatrics
Worcester, Mass.

Pilar Sousa-Schwalb, M.A.
Virginia Commonwealth University
Medical College of Virginia
Virginia Treatment Center for Children
Richmond, Va.

Nicolee Teegarden
Art Department, Tremper High School
Kenosha, Wis.

Belinda G. Todd, M.A., A.T.R.-BC
Milton, N.Y.

Psychosis

Marygrace Berberian, A.T.R.
Hartley House
New York, N.Y.

Wendy Bradley, M.S.
Bronx Children's Psychiatric Center
Bronx, N.Y.

Pandora Peterlik, M.S.
Ethan Allen School
Wales, Wis.

Mary Sheehan, M.A., A.T.R.
Medical College of Virginia
Virginia Treatment Center for Children
Richmond, Va.

Mia Stuesser, M.A., A.T.R.
Fuller IRTP
Boston, Mass.

Kim Tabatt, M.A.
Brunswick Hospital Center
Psychiatric Department
Amityville, N.Y.

Attention Deficit Hyperactivity Disorder

P. Gussie Klorer, Ph.D., A.T.R.-BC
Southern Illinois University at
Edwardsville
Edwardsville, Ill.

Diane McLeester, A.T.R.-BC
North Hudson Academy
North Bergen, N.J.

Ellen Perrin, M.D.
University of Massachusetts Memorial
Medical Center
Department of Developmental &
Behavioral Pediatrics
Worcester, Mass.

Agneta Persson
Puerto Rican Family Institute
Day Treatment Program
New York, N.Y.

Diane Safran, A.T.R.-BC, LMFT
Attention Deficit Disorders Institute
Westport, Conn.

Mary Sheehan, M.A., A.T.R.
Medical College of Virginia
Virginia Treatment Center for Children
Richmond, Va.

Nicolee Teegarden
Art Department, Tremper High School
Kenosha, Wis.

Peter Woronoff, A.T.R.
North Hudson Academy
North Bergen, N.J.

Learning Differences

Lisa Bingham
Fessenden School
West Newton, Mass.

Valerie Bostory, M.A.
The Jewish Board of Family and
Children's Services, Inc., at the Henry
Ittleson Center for Child Research
Riverdale, N.Y.

**Beth Gonzalez-Dolginko, M.P.S.,
A.T.R.-BC**
Hofstra University
Hempstead, N.Y.

Janet K. Long, M.A., MFCC, A.T.R.-BC
University of California, Berkeley
Children's Hospital Oakland
Oakland, Calif.

Ann Northup
Diamond Middle School
Lexington, Mass.

Linda A. Snyder, LDTC
Harding Township School
New Vernon, N.J.

David Wall
Fessenden School
West Newton, Mass.

Martha Winston
Fessenden School
West Newton, Mass.

Pervasive Developmental Disorders and Autism

James D. Calvert, Ph.D.
Child and Family Guidance Centers
Dallas, Tex.

Sharon DeNault, M.A.P., A.T.R.
Allied Services Rehabilitation Hospital
Scranton, Pa.

Robin F. Goodman, Ph.D., A.T.R.-BC
New York University Medical Center
Stephen D. Hassenfeld Children's Center
for Cancer and Blood Disorders
New York, N.Y.

Debra Howard
Groden Center, Inc.
Providence, R.I.

Beverly Rodgerson, M.A.
St. Elizabeth School and
Habilitation Center
Baltimore, Md.

Belinda G. Todd, M.A., A.T.R.-BC
Milton, N.Y.

Post-Traumatic Stress Disorder

Caryl Dalton, Ph.D.
Austin, Tex.

Lynne (Beldegreen) DiCandido, M.A., A.T.R.-BC
New York, N.Y.

Angela Esposito-Tardiss,
St. Luke's — Roosevelt Hospital Center
Child and Adolescent Psychiatry Clinic
New York, N.Y.

Victor Fornari, M.D.
North Shore University Hospital — New York University School of Medicine
Manhasset, N.Y.

Robin Gurwitch, Ph.D.
University of Oklahoma Health Sciences Center
Child Study Center
Oklahoma City, Okla.

Francie Lyshak-Stelzer, M.P.S., A.T.R.-BC, CGP
Bronx Children's Psychiatric Center
Bronx, N.Y.

Abuse

Amy K. Backos, M.A.
Cleveland Rape Crisis Center
Cleveland, Ohio

Helen Ellis, M.S., A.T.R.
The Children's Aid Society
Foster Care Services
New York, N.Y.

Gwen B. Schneider-Johnsen, M.A., A.T.R.-BC, LPC
Arthur Brisbane Child Treatment Center—Phoebe's Place
Farmingdale, N.J.

Mia Stuesser, M.A., A.T.R.
Fuller IRTP
Boston, Mass.

Käthe Swaback, M.A., A.T.R.; Julie Duffy, M.A.; Kit Jenkins, M.A., A.T.R., LMHC; and Mary Flannery, M.A.
Raw Art Works
Lynn, Mass.

Nicolee Teegarden
Art Department, Tremper High School
Kenosha, Wis.

Divorce

Margaret J. Byrnes, M.A., LCPC
Mercy Hospital and Medical Center
Mercy Medical Health Center
Chicago, Ill.

Rachel Cherry, M.A., A.T.R.
Center for Domestic Violence Prevention
San Mateo, Calif.

Patty Cole Gregory, M.S.W.
Atlanta, Ga.

Lisa Kay, A.T.R.-BC, LCPC, and Pat Quinn, A.T.R.
Catholic Children's Home
Special Education School
Alton, Ill.

Sarie E. Mai, R.N., R.Mid., A.T.R.
Ottawa General Hospital
Department of Psychiatry
Child and Family Psychiatric Unit
Ottawa, Canada

Catherine Matthews, Ph.D.
Lubbock, Tex.

Kristi B. Rothenburger
Art for the Family Builders
Program of Louisville
Louisville, Ky.

Physical Illness

Adrianna Amari
The Kennedy Krieger Institute
Baltimore, Md.

Susan Franklin, R.N., P.N.P.
University of Massachusetts Memorial
Medical Center
Department of Pediatrics
Worcester, Mass.

Robin F. Goodman, Ph.D., A.T.R.-BC
New York University Medical Center
Stephen D. Hassenfeld Children's Center
for Cancer and Blood Disorders
New York, N.Y.

Julie LaBounty, C.C.L.S.
Texas Children's Hospital
Houston, Tex.

Belinda G. Todd, M.A., A.T.R.-BC
Milton, N.Y.

Wendy Ward
Columbia Presbyterian Medical Center
Babies and Children's Hospital of
New York
New York, N.Y.

Lori S. Wiener, Ph.D.
Pediatric H.I.V. Psychosocial Support
Program
National Cancer Institute, National
Institutes of Health
Bethesda, Md.